Plough Quarterly

BREAKING GROUND FOR A RENEWED WORLD

Autumn 2018, Number 18

T0151895

Artists: Denis Brown, JR, Valérie Jardin, Isaiah King, Isaiah Tanenbaum, George Makary, Oriol Malet, Alex Nwokolo, Ashik and Jenelle Mohan, Caravaggio, Raphael, Aaron Douglas, Winslow Homer, Vincent van Gogh, Wassily Kandinsky

Plough Quarterly

WWW.PLOUGH.COM

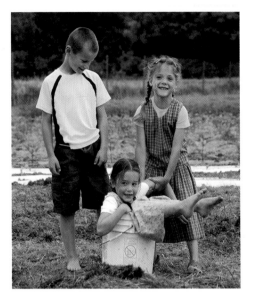

Meet the community behind *Plough*.

Plough Quarterly is published by the Bruderhof, an international community of families and singles seeking to follow Jesus together. Members of the Bruderhof are committed to a way of radical discipleship in the spirit of the Sermon on the Mount. Inspired by the first church in Jerusalem (Acts 2 and 4), they renounce private property and share everything in common in a life of nonviolence, justice, and service to neighbors near and far. The community includes people from a wide range of backgrounds. There are twenty-three Bruderhof settlements in both rural and urban locations in the United States, England, Germany, Australia, and Paraguay, with around 2,900 people in all.

To learn more or arrange a visit, see the community's website at *bruderhof.com.*

Plough Quarterly features original stories, ideas, and culture to inspire everyday faith and action. Starting from the conviction that the teachings and example of Jesus can transform and renew our world, we aim to apply them to all aspects of life, seeking common ground with all people of goodwill regardless of creed. The goal of *Plough Quarterly* is to build a living network of readers, contributors, and practitioners so that, in the words of Hebrews, we may "spur one another on toward love and good deeds."

Plough Quarterly includes contributions that we believe are worthy of our readers' consideration, whether or not we fully agree with them. Views expressed by contributors are their own and do not necessarily reflect the editorial position of *Plough* or of the Bruderhof communities.

Editors: Peter Mommsen, Veery Huleatt, Sam Hine. Creative Director: Clare Stober. Art director: Emily Alexander. Designer: Rosalind Thomson. Managing editor: Shana Burleson. Contributing editors: Maureen Swinger, Susannah Black.
Founding Editor: Eberhard Arnold (1883–1935).
Plough Quarterly No. 18: The Art of Community
Published by Plough Publishing House, ISBN 978-0-87486-057-3
Copyright © 2018 by Plough Publishing House. All rights reserved.

Scripture quotations (unless otherwise noted) are from the New Revised Standard Version Bible, copyright © 1989 the Division of Christian Education of the National Council of the Churches of Christ in the United States of America. Used by permission. All rights reserved.

Cover art by Denis Brown: *quillskill.com.* Inside front cover: Image reproduced by permission from JR. Artwork on page 32 by George Makary: *gmcopticicons.com.* Artwork on page 37 by Fadi Mikhail: *ukcopticicons.com.* Back cover: painting by Wassily Kandinsky © 2018 Artists Rights Society (ARS), New York. Digital Image © The Museum of Modern Art/Licensed by SCALA / Art Resource, NY.

Editorial Office	*Subscriber Services*	*United Kingdom*	*Australia*
PO Box 398	PO Box 345	Brightling Road	4188 Gwydir Highway
Walden, NY 12586	Congers, NY 10920-0345	Robertsbridge	Elsmore, NSW
T: 845.572.3455	T: 800.521.8011	TN32 5DR	2360 Australia
info@plough.com	subscriptions@plough.com	T: +44(0)1580.883.344	T: +61(0)2.6723.2213

Plough Quarterly (ISSN 2372-2584) is published quarterly by Plough Publishing House, PO Box 398, Walden, NY 12586.
Individual subscription $32 per year in the United States; Canada add $8, other countries add $16.
Periodicals postage paid at Walden, NY 12586 and at additional mailing offices.
POSTMASTER: Send address changes to *Plough Quarterly,* PO Box 345, Congers, NY 10920-0345.

The Art of Community

PETER MOMMSEN

Dear Reader,

"Beauty will save the world," runs a line by Dostoyevsky much quoted by Christian art lovers. Yet it's not at all obvious that beauty, at least the artistic kind, can do any such thing. Nor should Christians expect it to. Jesus himself seems to have preferred the lilies of the field to the artful adornments that arrayed Solomon, and his most active apostle, Paul, famously antagonized the sculptors' guild in Ephesus.

Repeatedly in church history, movements of renewal have been deeply skeptical of art, from the original iconoclasts, who among other things sought to restore the early church's simplicity, to Savonarola, to the Reformers, to the Puritans. As a pithy hymn by an Anabaptist martyr from the 1520s puts it: "Beauty and art – these cannot bring you to God. They stink before him and are good for nothing. Strive instead for humility."

Iconoclasts generally haven't fared well at the hands of historians, who dismiss them as gloomy fanatics. Nevertheless, their conviction that beauty may damn as often as it saves has today found a home within art itself. Contemporary art, whether visual, musical, literary, or architectural, is marked by its suspicion of beauty. We moderns have learned that the beautiful is often a mask for barbarity. Schubert performances were beloved by the guards in Auschwitz.

And yet: an equally ancient strain within Christianity insists that there *is* a beauty that can save the world. In the Greek translation of the Hebrew Bible that the early Christians used, when God in Genesis pronounces his creation good, he says of earth, plants, animals, and humans: "It is beautiful." In that sense, the medieval theologian Nicholas of Cusa understood the creativity of the artist to reflect the creativity of the Maker of heaven and earth. The Romantics were at least partly right: the artist who creates beauty can be a channel for divine truth.

This isn't just a high-flown theory, as anyone can attest who has joined with others to sing Bach's *Saint Matthew Passion* or to stand before a painting by Raphael or Chagall. At such moments, art creates a community bound together by the beautiful, the good, and the true – that is, by God. This issue of *Plough* focuses on art that leads to such community: through theater (page 10), iconography (26 and 32), music (82 and 90), and the objects and architecture of everyday life (18).

But that is still only a part of the picture. It isn't just that art can foster community. Christian community, the daring attempt to live and work together in justice and peace, is itself a work of creativity: a work of Jesus' Spirit, as Eberhard Arnold writes on page 65. This is the beautiful – if often difficult – adventure to which, in the end, each human being is called.

Warm greetings,

Peter

Peter Mommsen
Editor

> **Christian community is itself a work of creativity.**

LaShun Beal,
Deep in Thought
(detail)

Addiction and the Soul

On Mark Schloneger's "Let Me Stand," Summer 2018: Thank you for writing with such insight and feeling about your sister Trisha, who died of an opioid overdose. I love my "Trisha" and see her in every word of this story. She is walking this path and is in jail right now. She is loving, giving, and caring, and her vulnerability is both her strength and her weakness. I pray the author will receive forgiveness and healing from God. Then he will be able to help others heal from their shame and their addiction.

Betsey McCarley

Let None of Us Be Erased

On Sarah C. Williams's "Perfectly Human: What My Daughter Taught Me," Summer 2018: I have been physically disabled since infancy because of a genetic disease, and find this article terribly beautiful and true. I am virtually a quadriplegic and have difficulty breathing because of my severe weakness and skeletal deformities. Is my life a "suboptimal life"?

When my doctor uses the term "quality of life" I always feel a little nervous, as though my life may someday be judged useless and expendable. If physician-assisted suicide continues to be legalized, then someday I may very well be given the choice. Yes, the choice: "Do you want to end your suffering?" I may be asked. By "suffering," the well-meaning professional would mean my life. Even if it is considered severely suboptimal, I would not wish to end my life. But, if I were forced to make such a decision, would I feel selfish and guilty if I chose to continue to live with other people taking care of me?

The little life of Cerian is not to be dismissed. We are all little. Let none of us be erased. Thank you, Sarah, for sharing your story!

Christina Chase, New Hampshire

Transgenderism and the Theology of the Body

On Angela Franks's "What's a Body For?," Summer 2018: Thank you for this helpful summary of the theology of the body. I think it is worth pointing out, however, that until we understand genetic influences on personality inclinations we need to be careful of how we speak about transgenderism.

Romans 1 describes how people began rejecting what could be known of God naturally. Verse 18 describes how they stubbornly rejected the sense of morality which had been given to them and God judged them by just letting the natural consequences happen. Here we gain a theological insight into our genetic inheritance and negative family, tribal, and territorial character traits. We do not control who we are: we are the product of our heredity, our environment, and the choices we make. These choices have effects on our descendants.

To claim that transgenderism "requires that there be no intrinsic link between the body and the person" is not the perspective of every individual involved. It would be more accurate to say that "for many trans persons the body needs to be modified to enable them to express who he or she really is." Why not accept that if this perspective can be recognized, as Franks does for other redesign surgeries, that trans surgery in these cases could help enhance the body's ability to express a person's self-gift?

Franks believes that objectification of the body is a pivotal issue for medical ethics: "If the body is simply clay in our hands, why

not make it differently gendered? Or make our children as smart and blond as possible through genetic engineering? Or upload our minds to computer databases and discard the body altogether? All of these approaches make the body a problem to be fixed or eliminated."

She points to a significant basic issue for medical ethics and she has raised valid questions. But she seems to think that those questions can be answered in only one way when, actually, there are nuanced affirmative answers to at least some of the questions she raises: for example, my suggested answer to the question regarding transgenderism above. Genetic engineering that would prevent disabling genetic conditions from occurring in newborns, along with gene therapy for diseases in adults, also seems to have the possibility of "enhancing the body's ability to express a person's self-gift," which seems to be Franks's primary criteria for judging when technological manipulation of the body may be justified. Each individual's situation should be evaluated on its own merits, and I hope that Christian counselors who assist those with questions will take this approach.

James R. Johnson, Pittsburgh, PA

Angela Franks responds: I would like to thank James R. Johnson for his response. His key contention is that "trans surgery could help enhance the body's ability to express a person's self-gift" by modifying the body to match the person's perceived reality.

By comparing gender-reassignment surgery to the other kinds of surgery I mentioned (a C-section and a pacemaker implant), he assumes that our sex can be defective in the way that an irregular heartbeat is. But that is the point that I contest: sexual differentiation is an intrinsic part of God's design for our bodies. Maleness or femaleness is not an error or deficiency.

If a person views her sex as such – as an obstacle to self-expression and self-gift – then she is using her body as a screen upon which to project her anxieties. Those anxieties may be very real in someone with gender dysphoria. For healing to occur, however, the locus of the disease must be properly diagnosed: not in the body but in the psyche.

Ultimately, our alienation from our bodies is not a technological problem requiring a surgical solution. This alienation derives from original sin, which instituted a deep fracture within our persons, but this too Christ came to heal.

We welcome letters to the editor. Letters and web comments may be edited for length and clarity, and may be published in any medium. Letters should be sent with the writer's name and address to letters@plough.com. ➤

Love in the Void
Where God Finds Us
Simone Weil

Why is it that Simone Weil, with her short, troubled life and confounding insights into faith and doubt, continues to speak to today's spiritual seekers?

After her untimely death at age thirty-four, Simone Weil quickly achieved legendary status among a whole generation of thinkers. Her radical idealism offered a corrective to consumer culture. But more importantly, she pointed the way, especially for those outside institutional religion, to encounter the love of God – in love to neighbor, love of beauty, and even in suffering.

Colombia peacemakers' conference, 2018

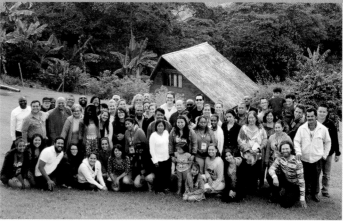

Ripples of Forgiveness in South Sudan

John Chol Daau, one of the "Lost Boys of Sudan," was forced to flee his village when it was attacked and destroyed by the Sudanese military. Years later, he has now returned to South Sudan and started a school in Juba with a vision of raising up a generation of Christian leaders to work for peace and justice in their war-torn country.

In recent months, John and his staff have been reading and discussing *Plough*'s book *Why Forgive?*, by Johann Christoph Arnold, and report that it has had a profound effect on their community, inspiring a movement toward forgiveness, reconciliation, and personal repentance. John writes, "We would read two chapters before we gathered for a two-hour discussion. It was such a discipleship class, a bonding session, and a teaching opportunity. We had heated discussions about issues such as polygamy and forgiving extremists. We ended with a day of reflection to which teachers and staff brought their friends and spouses." As a result one man publicly forgave a soldier who had shot him two years ago.

Building Peace in Colombia

Since 1958, more than 220,000 people have died in Colombia's civil war. Now, as a tenuous peace takes hold, Mennonite Colombians are actively working to heal their country's wounds and divisions through forgiveness. A peacemakers camp this summer brought together about fifty people from Guatemala, Mexico, Australia, the United States, and Colombia – including former combatants and victims – for fellowship and workshops on conflict resolution, conscientious objection, and victim–offender dialogue. Jardely Martinez, an event organizer, said, "Our vision is to have an open space, a place of peace where God can hear us and we can hear the history of each person who has suffered the consequences of war." Attendees received copies of *Plough*'s *Setenta veces siete: reconciliación en nuestra sociedad,* the same book making waves in South Sudan.

Poet in This Issue:
Cozine Welch Jr.

At age seventeen, Cozine Welch Jr. was sentenced to twenty-two to forty years in a Michigan prison. While incarcerated he became the most published writer in the *Michigan Review of Prisoner Creative Writing*, appearing in nine consecutive volumes. Since being released last September he has been published in the *Michigan Quarterly Review, Periphery,* and other journals. He is currently co-teaching the Atonement Project at the University of Michigan, a course that focuses on restorative justice, reconciliation, and atonement. A lyric poet and performer of slam poetry, he is also an accomplished guitarist, singer, and songwriter. His poems "look . . ." and "reenter" appear opposite and on page 48. ⤳

Alex Nwokolo,
The Special One,
mixed media, 2011

look ...

I sip earl grey from a
stained plastic cup
the open window chills me
but
I dare not close it
it cools the heated temperaments
that surround me, growling,
grumbling, finding
further proof of personal slights
and insults in the
late calling of our unit
to chow
to yard
to dayroom
to gym
in the
sag of my pants
the ink on your skin
gauge in his ear

the worse or better
pronunciation of letters
in the
cultural conditioning that
positions me
above, below
allied, opposed
to you
I sip earl grey and bring
mindfulness to the fore
clear awareness
gives me clarity
of perception
an insight
into the inner side of this that,
from experience,
I know I cannot adequately translate
language is lacking
there is only a finger
pointing the way

COZINE WELCH JR.

Summer of the Tree House

MAUREEN SWINGER

Homely House, built summer 2018

What was your childhood dream house? Mine was a string of graceful pavilions and bridges high among the crowns of a forest of mallorn trees (of the eternally golden leaves, for "on the land of Lórien no shadow lay.")

My children lean toward Shire dwellings, with their cozy circles and arches and welcoming old wing chairs drawn close to warm hearths.

Well, long live imagination. But what do you do when one of those would-be shire-dwellers asks if we can build our own Bag End? It's all very well for shire-folk to tackle earthworks, earthworms, and a lot of earth overhead. Airy elven tree dwellings perched at dizzying heights seemed equally beyond our grasp. I'm not as good as I was with ladders. Also, mallorns don't grow here.

Frodo unexpectedly solved our dilemma when he arrived at Rivendell, and felt safe in "the Last Homely House east of the Sea."

Homely House! My fellow Americans, here at least our dictionary can't stand up to Tolkien's Oxfordian tome, where *homely* means "simple but cosy and comfortable, as in one's own home." Even Noah Webster thought that description better than "not attractive or good-looking." Such a definition gives us license to build something both airy and cozy, and maybe twelve feet off the ground.

Thank goodness for people who live in the real world and build real houses. My husband is one. Jason maps out a building that sounds plenty real: human-scale, structurally sound, weatherproof. We don't actually see any plans; they're in his head, where they can be altered at will. Round window in the door? Could be fun. A fanlight set into the curve of the half-moon roof? Let's see if it works.

Oldest daughter asks about a built-in bookshelf. Youngest daughter longs for a swing. Son just wants to get out the hammer already.

Maureen Swinger is an editor at Plough *and lives in Walden, New York, with her husband, Jason, and their three children.*

The scouts find the perfect location: just past the edge of a meadow, "through the merry flowers of June, over grass and over stone," the hillside drops steeply through a grove of sugar maples. They can't find four trees close enough to create a platform base. But they do find three, so they dig a hole and plant a locust log for a fourth point.

Then the rainiest summer in living memory begins. We've got lumber, decking, shingles, collected remnants from carpentry projects. The big picture window has been leaning at a perilous angle in a ramshackle barn for untold years. Everything, in fact, is in that barn, waiting for a sunny weekend which refuses to materialize.

So we make our own fate: Homely House is going to be pre-fab, built wall by wall in the old barn half a mile from its trees.

Everybody pitches in to assemble and stain and hammer; "No, not there! Here!" For some of the higher carpentry, the rest of us watch and ask too many questions. But the walls rise, the arched rafters line up patiently, and the door gets its round window. Youngest daughter goes through the door-window several times, just because we can't.

On the first sunny Saturday in July, friends join us on the hillside to bolt together the platform and run it onto its base. Since we stood here last, the locust log has become a tree again, with fans of bright leaves shooting out on all sides. Thanks, rain.

It's been a family-and-friends project; roof-raising happened last week. Now we're applying finishing touches and scheming up plans for the immediate surroundings. Hobbit-sized picnic tables? A fire-pit? Somebody practical suggests an outhouse. Maybe others will add their visions.

We hope Homely House becomes a camping spot for families and a destination for children from the nearby school. It's also a few hundred yards from our *Plough* offices, and my colleague Nancy plans to proofread there in uninterrupted solitude. We may need a store of pipe-weed.

The Summer of the Tree House has been lively. Less swimming, more sweating. Encounters with wasp nests and boards dropped on toes. All for a visit to Tolkien-land? It's not for that, but I'm at a loss to say what it *is* for. Perhaps I may quote JRR: "The world is indeed full of peril, and in it there are many dark places; but still there is much that is fair." If a child learns that fact, even from a tree house, maybe she'll be less likely to answer: "We don't want any adventures here, thank you! You might try over The Hill or across The Water."

Of course, we know how that worked out for Bilbo. ⤳

▶ *Watch the planning and construction of Homely House at* plough.com/treehouse.

Warriors on Stage

SCOTT BEAUCHAMP

For military veterans, the arts can help – but can they heal?

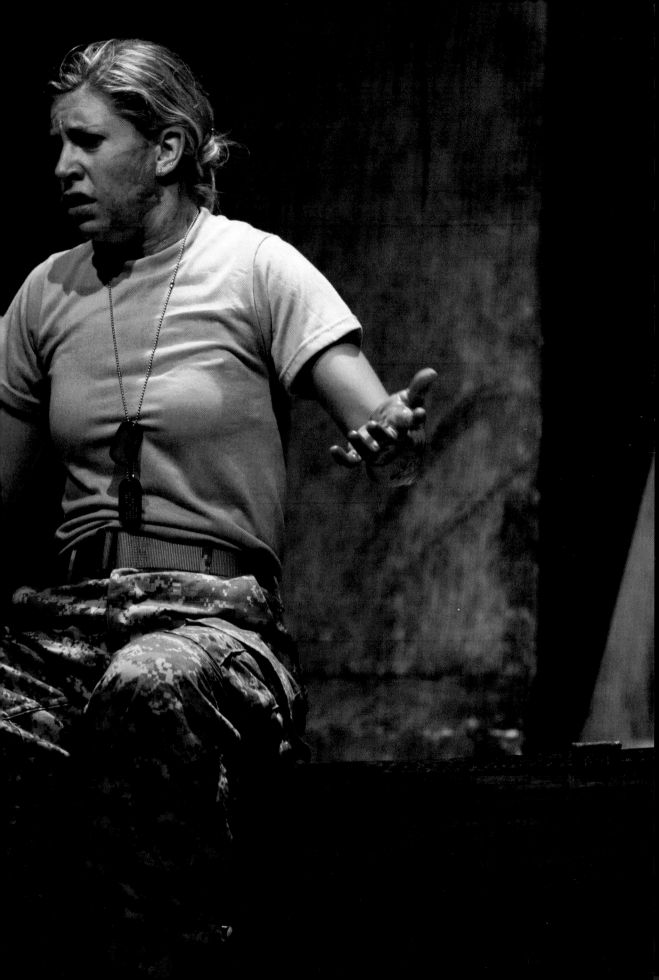

I returned from my first deployment to Iraq as an infantryman in late 2007, but I still heard the war – it was alive in the voices of my fellow soldiers. There was a rawness to them, a balance between elation at having survived and the pain of the experience. The military communities in Germany, my duty station, were bubbles where everyone saw each other in the same bars. It was a social hothouse. Drunken soldiers would perform their pain with one another in predictable ways.

Photo on previous page: A production of Ellen McLaughlin's play *Ajax in Iraq* by the Flux Theatre Ensemble

I began to call it "The Bluster." They'd take any excuse – a jostle, a joke, a glance – to start a confrontation. They repeated certain phrases: "I'm already going to hell, so what does it matter if I kill one more person?" It was sad, of course. But The Bluster was also so over-the-top, so out of proportion to whatever slight had triggered it, that it was hard to take at face value. Instead, it seemed a dramatization of the guilt and anger of war itself. The beer-soaked bar floors felt like a stage and the veterans like actors in a production in which they only dimly realized they had been cast.

Returning warriors publicly performing their guilt and anger: it's a phenomenon with ancient roots. As Bryan Doerries explains in *The Theater of War,* much Attic Greek drama was intended to speak to the pain of people enmeshed in combat. These plays were not simply lurid stories. Rather, playwrights understood that "live drama had the power to convey the spirit of an ultimately indescribable experience."

The original audiences of Greek drama were veterans suffering the wounds of war and the civilians to whom they returned. For veterans, the experience of war demanded articulation. This could purge it of its power to swamp them in pain. For civilians, the realities of war needed dramatization. This could bridge the gap that now existed between them and their returned brothers, fathers, and sons. Doerries writes that for the Greeks, "Storytelling, philosophy, art, and war were vitally and inextricably interconnected. Perhaps one of the most overlooked yet crowning achievements of this ancient democracy . . . was the wholesale use of the arts to communalize the experience of war."

Bringing the experience of war into the community is the animating purpose of Doerries's Theater of War Project. His purpose, as he states on his website, is to forge a "public

Scott Beauchamp is a writer and veteran whose work has appeared in Paris Review, Atlantic, *and* New York Magazine, *among other places. His book* Did You Kill Anyone? *is forthcoming from Zero Books. He lives in Maine.*

vocabulary for openly acknowledging and discussing the impact of war on individuals, families, and communities." By presenting readings of Sophocles' *Ajax* and *Philoctetes* by actors such as Jeffrey Wright, Adam Driver, and Martin Sheen to military and civilian communities, the Theater of War Project hopes to accomplish what Athenian theater did: "to destigmatize psychological injury, increase awareness of post-deployment psychological health issues . . . and foster greater family, community, and troop resilience."

Greek drama is particularly suited to these tasks, Doerries says, because the tragedies were "designed to elicit powerful emotional, biochemical, and physiological responses from audiences." Tragedy, he argues with a nod to Aristotle, aims to arouse and then purify strong negative emotions. Tragedy thus is a powerful tool for positive change. The goal of tragic drama, according to Aristotle's *Poetics,* is catharsis – a purging of the soul through the play's power to evoke pity and fear.

By this account, the way that Greek tragedy "works" bears some resemblance to contemporary exposure therapy. By exposing veterans to familiar but terrifying psychological states through actors on a stage – a safer setting than either the battlefield or their individual psyches – their feelings about combat can be purged of their toxicity. It's worth taking a moment to consider what this toxicity looks like when it's left to fester. Since what has come to be called the Long War against global terrorism began, American citizens have been made more aware of post-traumatic stress disorder, or PTSD. Despite the modern acronym, psychological distress from combat is as old as combat itself, though it's gone by other names: *soldier's heart* in the American Civil War, *shell shock* in World War I, *combat fatigue* in later wars. Each of these shifting terms, which reflect the social and political understandings of their time, attempt to name a wide spectrum of negative human reactions when faced with violence, extreme fear, death, and the guilt of killing.

For the American soldier, what complicates and even exacerbates these symptoms is that war so often happens in a place very different from home. The line dividing home and battlefield is stark, and to return to a home you don't recognize and to friends and family who don't recognize you is profoundly disorienting. The clinical psychologist Jonathan Shay calls PTSD and its associated symptoms (such as hypervigilance and sleeplessness) the "primary injury" of a returning soldier.

> ## Psychological distress from combat is as old as combat itself.

But there's another, deeper element to veterans' suffering as well. As Doerries puts it in his book, "many veterans are suffering from something far more insidious, destructive, and complex than the neurological symptoms from exposure to war-related trauma. Rather, it is something of a spiritual and moral nature that . . . a growing number of prominent mental health professionals now refer to as *moral injury.*"

Shay describes moral injury as a sense of "betrayal of 'what's right' in a high-stakes situation by someone who holds power." Having served two deployments in Iraq as an infantry soldier, I know this sense of betrayal well. I'm intimate with it. And I can tell you that it cuts across the plane of your life completely, touching everything you hold dear, and metastasizing into an alien force dragging you beyond the event horizon of its terrible logic.

It begins with guilt, a sense of self-betrayal. When you kill, you feel set apart and secluded in your guilt. It's as if you're the only person ever to have killed another in combat, and you're burdened with a wrathful isolation. You blame yourself, of course, but the taking of another life is simply too consequential an event to stay confined in your individual persona. The guilt becomes larger than you. And so you blame the enemy. You blame the leaders who planned the mission. You blame your fellow soldiers, whom you told yourself you were protecting with your violence. You blame the civilians back home who don't – can't – understand. And finally, you blame your family for their love not being enough to save you from the dead weight of your moral culpability.

> **When you kill, you feel set apart and secluded in your guilt.**

"Moral injury," Doerries writes, "may, in fact, be the signature wound of the wars in Iraq and Afghanistan, not only during deployments but also when veterans return from war to pink slips, skyrocketing unemployment, and an apathetic, disengaged nation. Betrayal might just be the wound that cuts the deepest." And so here is where we find ourselves: with combat soldiers girding the world, endlessly deployed, and a veteran suicide rate of twenty people per day.

Our global War on Terrorism might be unique for its cutting-edge tactics and relentless pace, but the psychic wounds of the soldiers are timeless. There's a shock of recognition from veterans and their families who attend a Theater of War Project performance. They encounter human minds and hearts thousands of years distant, but familiar in their distress.

The first performance of the Theater of War Project was a reading of Sophocles' *Ajax*. You'd be hard pressed to find any drama, modern or ancient, more resonant with the anguish of combat. The plot is simple. The Trojan War has been raging for nearly a decade. Ajax, the greatest Greek warrior now that his friend Achilles has been killed, is losing his grip on reality. The armor of the dead Achilles should have been given to Ajax, but the kings award it instead to the wily and silver-tongued Odysseus. In a rage at his superiors and comrades – an anger that any combat veteran has likely witnessed – Ajax means to kill and torture his Greek allies. Temporarily confused by Athena, he instead slaughters the livestock taken as spoils of war. When Ajax comes to his senses and sees what he's done, he takes his own life, falling onto his sword after a final invective against Odysseus and the rest of the Greeks:

> The stern, far-ranging Furies. Let them mark
> How I am ruined by the sons of Atreus.
> Strike that evil pair with the harshest evils!
> Obliterate them! And as they see me fallen
> From a self-inflicted blow, so let them perish
> At the hands of their own beloved children.
> Come, you Furies, swift avengers! Glut your
> rage!
> Do not spare a soul in the army! And you
> Who steer your chariot along high heaven,
> Helios, when you spy my native land,
> Check your reins, all laden with gold,
> And tell my aged father and poor mother
> Who raised me of my disastrous downfall.
> *(Translation by Shomit Dutta)*

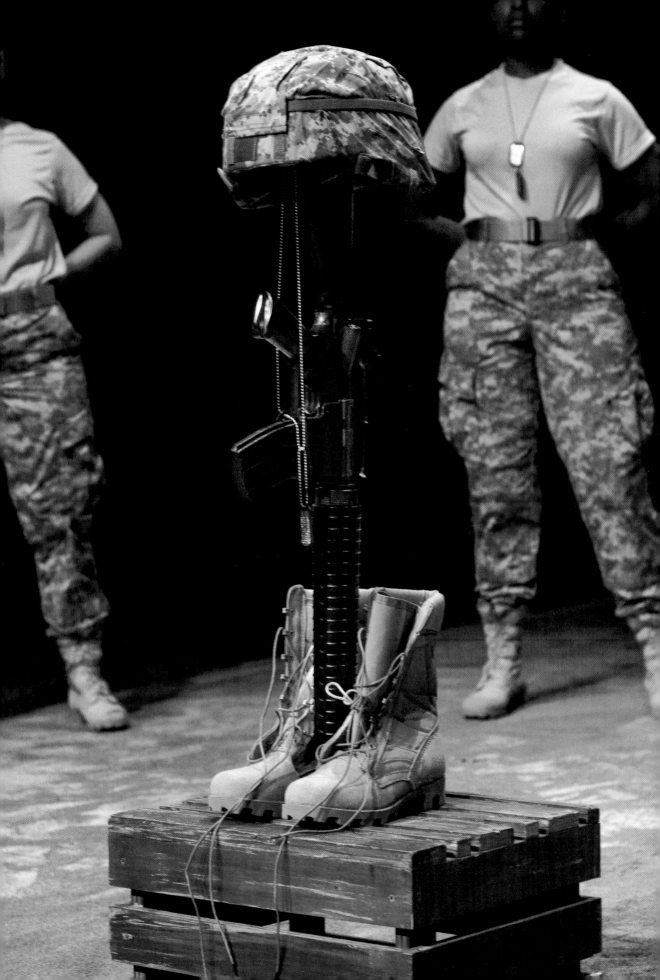

This is Bluster of a cosmic order. Feeling isolated from his family and betrayed by his comrades, Ajax murders himself. His death comes as a punishment to his allies, an unambiguous communication of pain to his loved ones, and a final confirmation of his isolation in the universe. It's no wonder so many veterans and their families have discovered that this ancient play speaks to their own incomprehensible anguish. It is uncannily familiar.

And yet it's almost equally alien. How far outside their original context can these tragedies be taken and still retain their integrity, their depth? Seeing them as we do now, stripped of their religious roots and cut away from the tight communities in which they were performed, are we not just playing at a cargo cult of tragedy? Doesn't the soul require deeper healing and more profound community than secular, government-sanctioned theatrical readings can provide?

Ajax, like most other Greek tragedy, is rich with gods. Its meaning is tethered to an Attic conception of reality, and it's hard to understand how a contemporary audience could separate aesthetic value and secular therapeutic use from a performance originally so bound up with religion. These plays simply aren't themselves without their transcendent order.

Ajax was probably first performed around 441 BC as part of the annual religious rite of the Great Dionysia, held every March in Athens. Historians suggest that this festival included both theatrical competitions in which playwrights staged newly-written tragedies, and accompanying rituals. The day before the performances animal sacrifices were made to a wooden image of the god Dionysus, which was then brought into the theater as a member of the audience. The mythological origins of this festival lay in an incident when Dionysus appeared to a group of women, who rejected him; to assuage his fury, they had to worship him. In this way, Attic theater in its depiction of blood and rage wasn't simply a cross between a Hollywood blockbuster and a therapy session. Rather, it was more like a powerful religious ceremony meant to soothe the anger of a god.

William James writes in "The Moral Equivalent of War" that the military experience is "a great preserver of our ideals" and "a permanent human obligation," without which life is insipid. The reason that many join the military in the first place, as James implies, is a desire for meaning. We have a hunger for coherence and depth that is difficult to find in the civilian world.

But too often that meaning for which veterans long remains absent from their experience. Once returned they still need healing, but the moral and psychological stakes are even higher, and the only real medicine for their wounds is meaning itself. The civic attempts that are made to confer or recognize the meaning of their experiences often fall short. When American veterans return home and are "honored for their sacrifice" at professional sports games or airports, this sacrifice is usually thought to be the time and effort of their service, the wounds that they have suffered, or even their willingness to die.

The sacrifice they have made that matters most is not addressed.

As Stanley Hauerwas writes in "Sacrificing the Sacrifices of War," the greatest sacrifice of war is the sacrifice of our unwillingness to kill. This is why war is at once "so morally compelling and so morally perverse. . . . This sacrifice often renders the lives of those who

BUSINESS REPLY MAIL

FIRST-CLASS MAIL PERMIT NO. 332 CONGERS, NY

POSTAGE WILL BE PAID BY ADDRESSEE

PLOUGH QUARTERLY
PO BOX 345
CONGERS NY 10920-9895

make it unintelligible." And so the returned veteran floats through the world, his sacrifice unnamed. Without this naming, redemption remains impossible. The strong medicines of community and meaning are withheld just when they're needed most.

Hauerwas also tells us of the long tradition of reintegration ceremonies bringing the warrior back into civilian life: Maasai purification rites; Roman bathing; Native American sweat lodges; Christian confession and penance before taking the Eucharist; even Greek tragedy itself. Programs such as the Theater of War Project, as laudable as they might be, ultimately fail to function with the same power as the predecessors they're trying to replicate, for two reasons: first, they're secular programs unable to address the spiritual wounds of violence; second, they are attempting to reintegrate the soldier into a larger society that is also fragmented, confused, and broken.

As harrowing as are the statistics on the mental health and suicides of returning veterans, the civilian world isn't much better. More than twenty percent of Americans will experience clinical depression. Suicide is increasing across all demographics of society. There are reports of a growing epidemic of loneliness, with people feeling disconnected and isolated from one another.

My transition back to civilian life, as smooth as it was, was marked by my shock at how listless and sad the civilian world was. Comrades who were almost like family slowly but surely lost touch. Our military experiences over, it felt as though we were drifting in the wreckage of a great ship, gradually drowning in the lonely depths of the larger world. We were acclimating, but to isolation, depression, and torpidity.

What exactly are veterans to be reintegrated into? Where is normal life? Hauerwas writes that the sense of betrayal, isolation, and silence that attends the moral injuries of war stands as an indication that we are made for reconciliation with one another and with God. In fact, how could we have one without the other?

The Bluster of my comrades was truly a struggle to communicate the desire for this reconciliation. Somewhere between the bravado and the pitifulness of The Bluster was a provocation leveled at the world: an injunction to break the silence. To see the wrong. To speak the truth.

And this is where we bump up against the limits of what art and psychology can achieve in an atomistic world denuded of transcendent hope. The Greeks had their gods and community. They had a shared language, derived from their deepest religious understanding, used to achieve an imperfect but profound shriving. Absent a language to speak to the spiritual nature of violence – to address sin and redemption with words adequate to the task – we're left silent, brooding, and unfulfilled.

> **What exactly are veterans to be reintegrated into?**

In Sophocles' play, after Ajax falls into insanity his wife Tecmessa asks, "How can I speak what is unspeakable?" When I think of the men and women I served with, I prefer to put the question another way: "Why does killing leave us speechless?" It's a question I asked myself often when I returned from war, a question posed pitifully and in isolation. The answer came to me with the slow comprehension that I wasn't just talking to myself: I was simply trying to pray.

Healing is to be desired, certainly. But our wounds require more. There can be no true healing without salvation. ⇀

The Beauty

Artists in the Christian tradition have been inspired by the New Testament stories, and one story in particular has prompted them to reflect on the nature of beauty and its place in our lives: the story of the Annunciation. In this story we encounter a moment of interaction between the human and the divine, when an angel appears in the most private and protected part of a woman's home. The light that radiates from the angel falls not only on Mary but on all the objects that surround her, showing the fitness of the woman for her holy task in the order and beauty of her room. *The Annunciation* by the Dutch master Joos van Cleve (1485–1540) illustrates the point (see page 21). None of the objects among which Mary sits is purely functional: everything has an edge, an embellishment, a kind of gentle excess. The furnishings are not just accidentally there: they are there because they are also owned, shaped, and cherished. Mary has arranged the room with beauty in mind, so as to be a fit welcome for an angel.

We find the same cherishing of objects in later Dutch interiors, when the secular vision had begun to replace the religious. In an

Sir Roger Scruton is a writer and philosopher who has published more than fifty books on philosophy, aesthetics, and politics. A fellow of both the British Academy and the Royal Society of Literature, he teaches at the University of Buckingham, England, and is a senior fellow at the Ethics and Public Policy Center in Washington, DC.

of Belonging

interior by Vermeer we see people set among objects that shine with the light of ownership. They have been brought into the house, so to speak, polished like mirrors, so as to reflect the lives and loves surrounding them. A kind of tenderness radiates from the objects in such paintings, to embrace the viewers and to tell them that they, too, are at home, among these things rubbed smooth by human affection.

In everyday life we are not animated, as a painter might be, by high aesthetic ideals. We are not trying to reveal the meaning of things, or to create compositions that convey a higher sense of order. Nevertheless we arrange things around us and try to make them fit together in something like the way they fit together in a painting, as when we lay a table for guests or arrange our room. Even in the most minimal

tidiness we subject the objects around us to a kind of moral discipline. We tell them: you should stand here, you two should be together, you are the wrong color, you are out of place, you are just the right shape to be there.

For whose sake are we doing this? Not for the sake of the objects themselves, for they have no "sake." Look at them as they are in themselves and they become inert, inanimate, awaiting our instructions. When we arrange them, however, we do so for the sake of people: not just this person here, who is laying the table, but any other person who might come along, who might even be a visitor from the realm of angels. While we think we are making one object fit to another, and each object fit to the whole, we are actually fitting the objects to an imagined community of people.

The idea of what is "fitting" takes its sense from a wider experience of community. People learn to adapt their behavior, their remarks, and their expressions to the demands and expectations of others around them, and this is what we mean by manners. It is from the resulting conventions, customs, and concessions that we draw our conversational repertoire. Knowing how to address a stranger in a new situation, how to move painlessly and quickly to a spirit of cooperation: these are not easy things to learn. But when we have learned them we have also learned something else: a comprehensive sense of the distinction between "fitting in" and "standing out." The most common form of rudeness involves standing out at all costs, drawing attention to yourself, regardless of whether you deserve it, dismissing attempts to fit in as the ploys of little people who cannot live in a more interesting way.

Good manners, therefore, mean fitting in. And our general sense of manners extends from people to objects, and from the domestic objects that accompany our daily lives to the wider environment, whether built or farmed or left as wilderness. Understanding this is the first step to grasping the role of beauty in the shaping of human communities. Ever since the rise of aesthetics as a philosophical discipline in the seventeenth and eighteenth centuries, writers and artists have tended to a transcendental view of beauty, as a value that lifts us above the things of this world to a realm of pure ideals. Beauty became the preserve of the artist, who could see through the muddles and compromises of ordinary existence to the sublime visions that only genius can perceive. This romantic idea misrepresents not only the concept of beauty, but also its place in the lives of ordinary human beings.

When we make aesthetic judgments we do not, as a rule, praise things as beautiful, sublime, or transcendental, in the manner of the romantic artist. We say instead that this is right, that wrong; this fits, that jars; and so on. In other words we extend the language of manners to the world of inanimate things, and in doing so we make them animate: we bring them into the community and subject them to the rules of good behavior. Hence "right" and "wrong" have a far greater role than "beautiful" and "ugly" in the aesthetics of everyday life, and that is as it should be, since everyday life aims at accommodation and equilibrium. It does not aim at the great experiences that shake us to the core, and which we can absorb, if at all, only on the special occasions when we are consciously exposed to them.

This does not mean that beauty has no place in ordinary things. On the contrary; it means that it does have a place, but a place

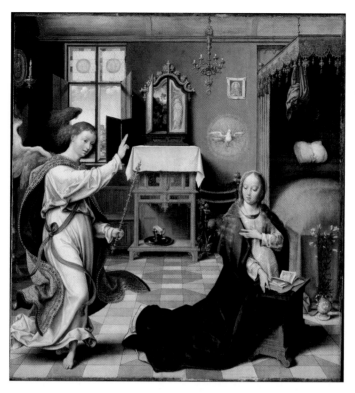

Joos van Cleve, *The Annunciation*

that is adapted to everyday experience, so as to guide our judgments of what fits, what harmonizes, what is right here and now. This judgment makes sense because it brings with it an incipient sense of community. It speaks for the indefinitely many others who stand at our shoulders when we ask the question whether this or that arrangement is right, or whether it "works." Everyday aesthetic judgment is profoundly rooted in the sense of community, and also forms a part of the collective effort whereby communities are brought into being and maintained in equilibrium.

There is no clearer proof of this than the cities bequeathed to us by former civilizations, where we gaze with wonder at the way in which every nook and cranny, every corner and parapet, is embellished with ornament and

fitted to its neighbor. We are presented with an overwhelming sense of a community united in its determination to be, in which buildings stand side by side in full acknowledgement of each other's right, in which space is something shared, and each detail offers itself to the eye as a subject of judgment.

Consider Venice. It is full of grand palaces, and contains the greatest interior of any building anywhere, the golden tent of Saint Mark's Basilica, encrusted with mosaics and shining with a light that is not of this world. But that is not, I think, what most inspires the visitor. More astonishing than Saint Mark's, more endearing than the church of Santa Maria dei Miracoli, more touching than the lace-like finish of the Ducal Palace, are the ordinary doorways on the backwater canals,

the marble-lipped bridges across them, the shrines and niches that punctuate the walls, the sense all about you of a meticulous but effortless aesthetic order, in which all the residents have willingly collaborated over centuries, so as to make their city, planted against the odds in the swamps of the Adriatic, the greatest shared space that has ever been made. There is not a wall, a doorway, a window frame, a roof, or a crenellation that has not been furnished in a spirit of love, adjusted not so as to express the power or grandeur of the would-be resident, but so as to embellish the space in which it stands. Things built in Venice have been built for *others*: the indefinitely many others who have been, are, and will be resident on these islands and conveyed through these canals.

This does not mean that the ordinary buildings of Venice are great works of art. Students of Venetian history will know that this tiny city, scarcely bigger than Greenwich Village, has throughout its history sustained every imaginable form of voluntary association, from the dignified *scuole* of the guilds and tradesmen to the masked balls of the aristocrats and the tournaments and *commedie* of the street. The city has existed in a continuous state of peaceful revelry and lawful self-government for a thousand years, and this great fact is written in the architectural palimpsest that shines on the water in every small canal. We should be in no doubt that the strength of Venice, its determination to defend itself right down to that final moment when Napoleon subdued the city to his grim project of a Europe united under French protection, was inseparable from its beauty. It is not brute force or wealth but beauty that inspired the citizens both to stand side by side against external aggression and to live harmoniously together by sharing what they had.

At a certain stage, as we know, all such efforts at a collective aesthetic fell into disrepute. Sometime in the run-up to the First World War the celebrated Austrian architect Adolf Loos informed us that "ornament is crime," and to whoops of delight from the architectural profession his bon mot became an aesthetic orthodoxy. Why did he say it, though? In late nineteenth-century Vienna, tenements and factories were springing up encrusted with irrelevant cherubs and ludicrous mouldings like the icing on decorated cakes. Ornaments once spontaneously adopted as part of the collective spirit of dwelling were now borrowed, stuck on, as though to disguise and sweeten a form that would otherwise protrude into the space of the city like a naked stranger. Ornament, in such circumstances, was not a step towards aesthetic order, but a pretense, a way that architects disguise what they are not prepared to affirm.

Americans have perhaps suffered more than others from the long-term effect of this assault on ornament. The late twentieth century gave rise to a raw, functional way of building, associated not only with architecture but with every aspect of daily life in which objects have a significant part to play. It is no longer things that are in the service of man, but man who is in the service of things. Shorn of all ornament, ostentatiously declaring that they are nothing but their function, objects defy our humanity, tell us to give up on the idea that we can relate to the world in some other way than by using it. We once believed that objects, like people, should be treated as ends in themselves, and not as means only. We wished for them to be, as in the great days of Venice, enchanted by their human uses, full participants in a community united by style. But that attitude to objects has been banished to the realm of

illusion. It is a fairy tale, like Father Christmas.

This has had devastating consequences when it comes to the design of towns and cities. American cities do not have nooks and crannies. Corners occur only because the sheer sides of curtain walls crunch together. There are no places "left over" from the great computerized forms that commandeer the ground plan, and nowhere can the little sheds, shrines, and shelters that barnacle our ancient cities gain a hold on the unornamented structures that in America stretch from the street to the sky. As a result of this, the city does not belong to its residents, nor they to the city.

When the day is over Americans flee from the downtown to the suburbs, where they can be at home in a place where ornament is allowed and things can look right. But the space of their aesthetic experiments is a constricted space, and its design is directed only to the family, and not to the wider community. The houses stand amid their swards of mown grass in no very clear relation, and although Americans are good neighbors and charitable people, their sense of community stops short of taking collective decisions as to how the neighborhood should be constructed so as to belong to them all.

Even so, wherever people build, decorate, and shape things with a view to belonging, a kind of order can emerge. For we are naturally home-building creatures, and this can be observed in that very American product, the trailer park. I say product, but of course it is more a by-product of poverty than a product in itself. Nevertheless, there is not a trailer-park in America in which the residents do not attempt to match the style, colors, and posture of the surrounding units, so as to make of their trailer a home among homes. We cannot settle without also making a settlement, that is to say, a place that is "ours." Our deepest social need is for the first-person plural of belonging, and to belong is to belong in a place.

And here, I think, it is important to look back to the beginning of human settlement. Human beings distinguished themselves from the rest of nature in the manner of the trailer-park resident, namely, by settling down. We settled down in a place, so as to farm it for food, and to be at home there. A settlement is not just a habitat, but a place that is claimed as "ours." And what was the first thing that we did to mark our patch of ground? It was to consecrate the place as sacred, and then to build a shrine.

Every great city in Europe was built around a church, and it is from the church and the temple that the vocabulary of classical ornament has been taken. What went wrong in Adolf Loos's day was not that ornaments were being abused – although of course they were – but that people had lost the faith from which the original habit of ornament stemmed. The cherubs and acanthus leaves, the mouldings and grape vines, had been stolen from temples from which the gods had fled, and put to profane uses. Architecture had been severed from its sacred origins, and desecrated. Loos's cry against ornament was like the cry of the seventeenth-century puritan against the Roman Catholic Church – a protest against the profanation of a shrine by the gaudy trappings of religious pretense.

I don't say that Loos was right. But I believe we should always bear in mind, when trying to understand what Milan Kundera has called "the uglification of our world," that these questions have much to do with long-standing disputes concerning the place of religion in everyday life. Who can doubt, on visiting Venice, that this abundant flower of aesthetic endeavor was rooted in faith and watered by penitential tears? Surely, if we want to build settlements today we should heed the lesson of Venice. We should begin always with an act of consecration, since we thereby put down the real roots of a community. ➤

> When we build settlements today we should begin always with an act of consecration.

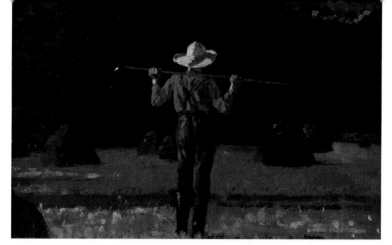

Winslow Homer, *Farmer with a Pitchfork*

INSIGHTS *on* BEAUTY

Jacques Maritain God is beauty itself, because he gives beauty to all created beings, according to the particular nature of each, and because he is the cause of all consonance and all brightness. . . . And every consonance or every harmony, every concord, every friendship and every union whatsoever among beings proceeds from the divine beauty, the primordial and super-eminent type of all consonance, which gathers all things together and which calls them all to itself.

Dorothy Day We have been accused of taking a morbid delight in the gutter and worshiping ashcans. The fact of the matter is that God transforms it all, so that out of this junk heap comes beauty. We have poetry and painting and sculpture and music and all of these things for the delight of the senses that are given to us right in the midst of filth and degradation and mires so that I often feel we know whereof we speak. God certainly comes to the rescue over and over again and enables us to do what seems utterly impossible.

Basil of Caesarea If sometimes, on a bright night, while gazing with watchful eyes on the inexpressible beauty of the stars, you have thought of the Creator of all things; if you have asked yourself who it is that has dotted heaven with such flowers, and why visible things are even more useful than beautiful . . . if you have raised yourself by the visible things to the invisible Being, then you are a well-prepared auditor. . . .

Truly, if such are the good things of time, what will be those of eternity? If such is the beauty of visible things, what shall we think of invisible things? If the grandeur of heaven exceeds the measure of human intelligence, what mind shall be able to trace the nature of the everlasting?

Annie Dillard We are here to witness the creation and abet it. We are here to notice each thing so each thing gets noticed. Together we notice not only each mountain shadow and each stone on the beach but, especially, we notice the beautiful faces and complex natures of each other. We are here to bring to consciousness the beauty and power that are around us and to praise the people who are here with us. We witness our generation and our times. We watch the weather. Otherwise, creation would be playing to an empty house. ⤳

Sources: Jacques Maritain, *Art and Scholasticism: With Other Essays* (Scribner, 1923). Dorothy Day, "Fear in Our Time," *The Catholic Worker*, April 1968, 7. Basil of Caesarea, *Hexaemeron VI*, "The Creation of Luminous Bodies," in *Nicene and Post-Nicene Fathers*, vol. 8, eds. Philip Schaff and Henry Wace (Eerdmans, 1989), 81–82. Annie Dillard, *The Meaning of Life*, ed. David Friend (Little, Brown, 1991).

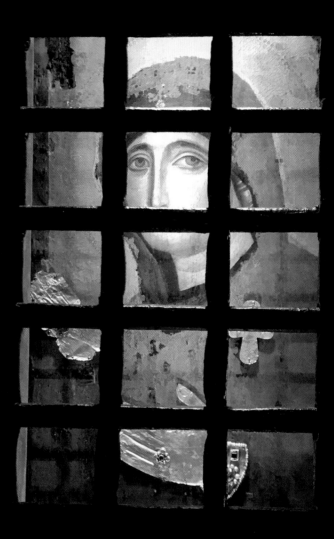

It Could Be Anyone

A Muslim writer contends with two Christian paintings

NAVID KERMANI

1 MY CATHOLIC FRIEND has written papers, only one of which I have read, about how he came across this picture. He would not exclude the possibility that it was painted by none other than the evangelist Luke. No laboratory analysis of the wood has been performed to date. The nuns are reluctant, he writes, because it's so brittle. But, even so, art historians have declared the painting definitely ancient, probably first-century. Ageless, the Virgin looked upon me, too.

My friend drove me to the convent, located on an ordinary residential street on Monte Mario, across the Tiber near the Hilton, and asked for the key at a little hatch in the side wall while I waited in the car. Before he led me to the chapel, where the nuns had turned the picture around for us, he peed in the bushes beside the iron gate. Ordinarily the Virgin

looks into the oratorium of the nuns, who have cloistered themselves away for life, neither receiving visitors nor traveling, nor even leaving the convent to walk to the shops. God suffices.

We saw a few of them through the barred window in which the picture is hung, and we heard all of them praying in the wan light, wimples past their chins, starched white habits, black veils. Five of the thirteen sisters are over eighty. Those sitting in the section of the pew that I could see through the window were no younger. Vast water stains stood out on the bare walls of their baroque church. My friend said the pipes were rotting, the phones didn't work, and repairs were out of the question until the convent had paid off its debts. The plea for donations is the part of their prayers that has yet to be fulfilled.

After a few minutes the nuns put out the light, after which we could only hear their voices: one verse low, one verse high, a singsong

A late classical icon of Mary the Advocate in Santa Maria del Rosario Church in Rome

Navid Kermani is an Iranian German writer and journalist who lives in Cologne. In 2015 he was awarded the Peace Prize of the German Book Trade.

interspersed with pauses, although I couldn't make out a word. My friend's book begins with a quotation from the retired pope: what it says is nothing new but always needs to be said anew. "Great things do not get boring with repetition. Only petty things call for variety and need to be changed quickly for something else. What is great grows greater still when we repeat it, and we grow richer, and become calm, and free." In Rome I was already growing envious of Christianity, envious of a pope who said sentences like that, and, if I hadn't thought the idea of God's incarnation in only one person fundamentally wrong and the world of Catholic concepts in particular so pagan, if I hadn't felt such a revulsion against the order that places all people and all human relations in hierarchies and against the demonstration of power in every Catholic church, not to mention the idolization of suffering to the point of bloodlust, I might possibly have gradually adopted its practices, attended the Latin Mass, and joined, with interspersed pauses, in the singsong, although initially more for aesthetic reasons, perhaps, and out of a fascination with the unparalleled continuity of an institution that forms the people of God into a community. It is the only one to have achieved that for so long. Who knows? Maybe the miracle that produced this most sumptuous of all heavenly

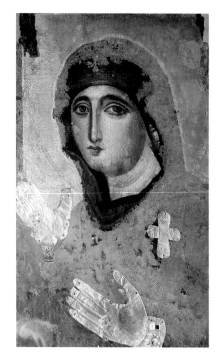

God has touched her. That is both grace and torment.

houses might one day have manifested itself to me too. As it is, while I continue to consider that this possibility is not reality, I acknowledge – and what's more, I feel – that Christianity is a possibility.

As if the darkness were not seclusion enough, invisible hands closed the shutters from inside so that we now saw only the icon, not the room behind it. Nothing is extant but Mary's face in the most astounding colors, the edge of her veil, two gilt hands, which could be pointing a way or signaling aversion, and the cross at the position of her heart – nothing else but her silhouette. And of course the gold background! The icon painters call it "light," my friend whispers, because the gold surrounds the saints like the light of Heaven. There is no side lighting, no imagined light source; instead, the colors themselves are light, and the lightest of them is the gold. As my friend withdrew to say a rosary, I had some time with the Virgin. But why do I call her Virgin if I don't believe in her as the Mother of God? One word: touched. God has touched her. That is both grace and torment; it raises up and strikes down; it is both a caress and the blow of a hammer. All is lost and God suffices.

Her big brown eyes look at you as if her much smaller mouth had cried at first, like the mystic Hallaj, "Save me, people; save me from

God." And so she did at first; she cried for help when she found out, I'm certain she did. "Glad tidings!" the kings bellowed, bringing gifts, but I am certain she was anything but glad. She carried it, bore it, as the saints bear it; that's what made her one – not being chosen, but being able to stand it. Having become an enemy of the state overnight, she fled, sleeping in barns, in cellars, and in the wilderness if necessary – it was a real wilderness two thousand years ago – her child always with her, and always her care, which was not increased or diminished by the question whether he was *a* or *the* son of God. Her care was that of every mother. Later she stood by as they struck him in the face, drove him with whips through the spitting mob, saw the thorns piercing deep into his brow, saw him carrying the cross, saw them nail him to it, saw the cross erected and the people jeering, saw her son hanging upon it, bleeding, groaning, thirsting, crying out in pain and despair hour after hour. Perhaps he was not the only one to look toward heaven and ask why God had forsaken him. Certainly the son looked down from the height at which the people displayed him towards his mother. Does the painting show her before or after that?

2 IT COULD BE ANYONE, any of the four men sitting around the little table, or the boy (see next page). It could be now, as Caravaggio teaches us by dressing the biblical crew, as today's auteur theater directors would, in contemporary costumes, contemporary to Caravaggio that is, the apostle in frills. Levi, as Matthew is still called in the Gospels of Luke and Mark, is so deep in concentration on counting the taxes he has collected today that he has not yet noticed the stranger pointing at him, or else he has noticed and is not looking up because he refuses to believe it. Or is a different one Levi? For four hundred years the viewers have not been able to agree even on that, sometimes identifying the bearded man as the future apostle, sometimes the one counting the money, seeing the three index fingers as pointing sometimes at the one, sometimes at the other. Apparently it's a matter for each observer to decide, and I should therefore ask myself why, from the first glance, I saw the one who is paying the least attention to the Savior as the one chosen. Jesus' companion Peter, in any case, seems to be reassuring the other tax collectors that he doesn't mean them; they can go on collecting taxes, day in and day out, feeding their families by preying on other families, leading ordinary human lives. Only to Levi Jesus says, "Follow me!" Not a word more does the Bible tell us about the vocation of Matthew: no reason, no explanation, and least of all any preaching or proselytizing, only: "Follow me!" And Matthew arose and followed him. In the Bible, the break with everything that had made up Levi's life up to that second is so abrupt and total that it can be understood – if not trivialized as hypnotism or clouded by the word charisma – only as a miracle. But Caravaggio is not interested in the miracle itself, because it cannot be represented, or if it can, it suddenly looks comical or in any case unnatural, as it did the one time he himself painted it, in the picture of doubting Thomas sticking his finger in Jesus' side as if it was full of air. Caravaggio is interested only in people. Of all painters he has the keenest eye for what the appearance of the Celestial means to terrestrials: it blows them apart. Caravaggio's pictures show, not revelation, but many variations on the torment of those to whom it is revealed; anyone who has once

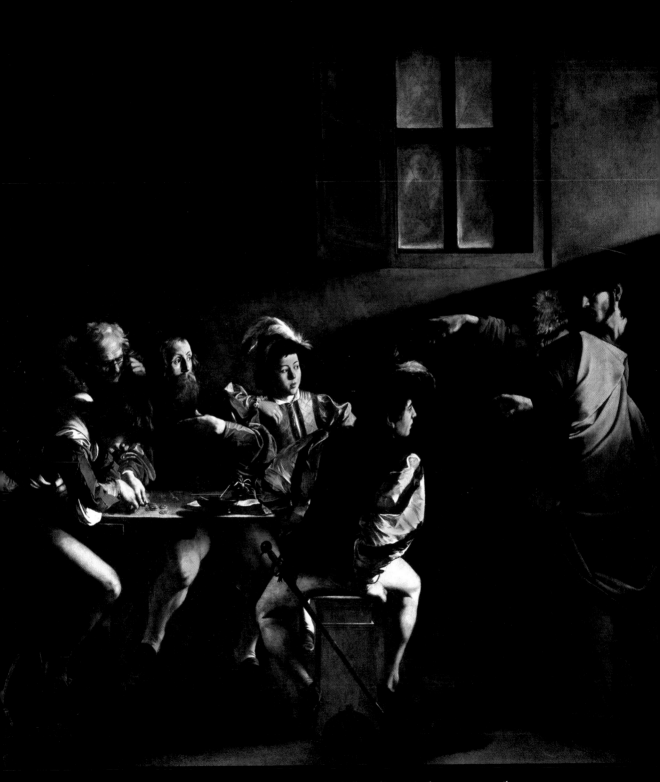

Michelangelo Merisi da Caravaggio, *The Calling of Saint Matthew*, 1599–1600, oil on canvas

lost himself in his paintings would not call it "glad tidings." "If you knew what I know, you would laugh little and weep much," says the Islamic Prophet, who foamed at the mouth and thrashed about in pain when the angel appeared to him, so that many thought he was possessed, epileptic, or mentally ill. "Is not my word like as a fire? saith the Lord; and like a hammer that breaketh the rock in pieces?" says the prophet Jeremiah (23:29).

In *The Calling of Saint Matthew,* Caravaggio captures, just once, the moment immediately before the calling, not the fact of being called. The picture itself offers no clue as to what is about to happen – which is what defines the situation. Of the five people sitting or standing around the table, Levi is the last one you would imagine, if you didn't know, as the man walking off after the stranger, his eyes glassy and his mouth hanging open like a sleepwalker's. Or, because the man counting money at the left is not necessarily Levi, perhaps we should say rather that you can't imagine it of any of them. That would mean that any person could be chosen. "Really, him?" asks the bearded man, while his bespectacled neighbor finds the coins more interesting. Or else, as other viewers have thought, the bearded man is saying, "Really, me?" The man in the foreground with the feather in his hat seems to understand nothing at all. He looks at Jesus only because the boy is kicking his shin under the table: "Yeah, what about it?" If you only look at the four men and the boy, covering up Jesus and Peter with a sheet of paper if you like, you can imagine

> The finger could point at anyone, at any time.

all kinds of things drawing their attention – a fight at the next table, the innkeeper collecting a tab, or a superior calling them to duty – but not the Redeemer in person approaching. Their amazement is not great enough for that; it's really just a sitting up and taking notice, a "What do you want?" That would mean the miracle is not the appearance of the Savior; the miracle is that someone notices it – and, if I am not mistaken, it is the one who pays the Savior no attention at all. The men will be stunned only when their colleague, from the next moment to the moment after that, abandons his family, his profession, and his view of the world.

That is Caravaggio's calculation in using contemporary clothes and the ambiguous direction of the pointing finger; that is his agenda in conceiving *The Calling of Saint Matthew* as one painting in a cycle that decorates a side chapel of the church of San Luigi dei Francesi in Rome. As if in warning, *The Martyrdom of Saint Matthew* on the opposite wall portrays where the calling leads. The cycle originally consisted of just these two paintings, which sufficed to state the essentials of the saint's life: random choice and sacrifice. The finger could point at anyone, any time. The door behind me could open and the person standing there could blow my life apart – the motif that German Romanticism loved: I had just left the house, not a thing on my mind, when suddenly . . . except that most of us are the others, the three other men and the boy, who watch the miracle happening and don't see it. ➤

This article is excerpted from Kermani's book *Wonder Beyond Belief: On Christianity,* translated by Tony Crawford (Polity, 2017). Used by permission of the publisher. *politybooks.com*

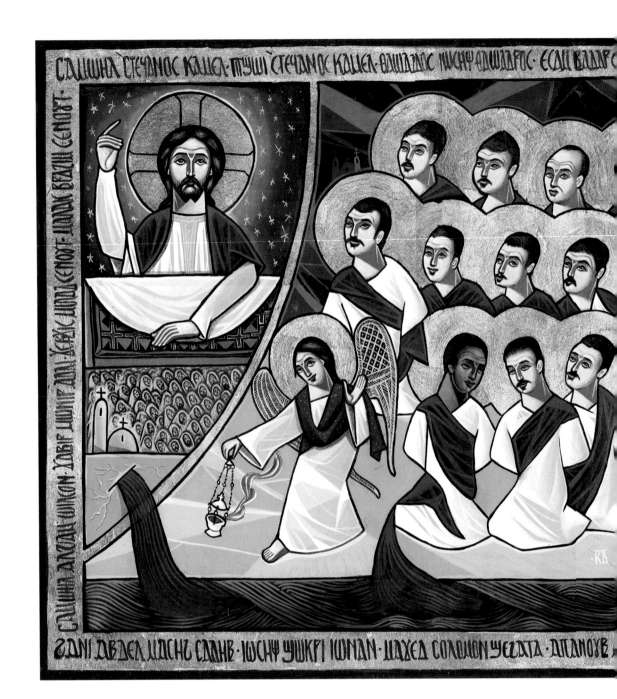

ALL ABOU✝ LIGH✝

FADI MIKHAIL

What should a modern icon look like?

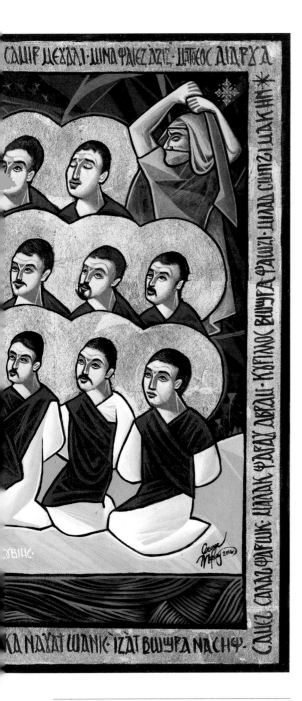

A 2016 icon by George Makary portraying the twenty-one Coptic Christians martyred by ISIS in Libya in February 2015.

I n 2015 the worldwide Egyptian community received the devastating news that twenty-one Coptic Christians had been martyred by the Islamic State. These Christians were soon declared saints of the Coptic Orthodox Church – a faith through which they would have been intimately familiar with the icons of saints who came before them.

The production of icons to venerate new saints is a richly rewarding task. But it also raises an important question: How can an iconographer portray a modern saint in a recognizable way, yet in a way that remains consistent with the abstract Coptic style?

As an iconographer for the Coptic Orthodox Church, I know this challenge well.

Early Christian Roots

Iconography has existed since humans learned they could create; it extends back to prehistoric cave paintings and sculpture. In Christianity, the tradition of sacred painting goes back to the earliest years of the church. The purpose of iconography is to call viewers to prayer and to educate them. According to the fourth-century church historian Eusebius,

Born to Egyptian parents and trained at The Slade School of Fine Art in London, Fadi Mikhail is an iconographer and oil painter who lives and works in England.

the first icons of Jesus were created before his Ascension. Although Eusebius himself disapproved of icons, he recalls visiting the house of the woman who, as recounted in the New Testament, had been healed by Jesus of a hemorrhage (Matt. 9:20–22):

> Upon an elevated stone, by the gates of her house, [there is] a brazen image of a woman kneeling, with her hands stretched out, as if supplicating. Opposite this is another upright image of a man . . . extending his hand toward the woman. At his feet, beside the statue itself, is a certain strange plant, which climbs up to the hem of the brazen cloak, and is a remedy for all kinds of diseases.[1]

Eusebius also mentions the case of King Abgar of Edessa, who received from Christ an image of Christ's face imprinted on a cloth, and was thereby healed of an incurable illness.

Icons like this cloth (and the Shroud of Turin) have been offered as evidence that the prohibition against divine images given by God to Moses in the Old Testament (Exod. 20:4–6) was overturned by the incarnate Christ. Indeed, it has been argued that the lack of images of God in the Old Covenant signified faith that no one had truly seen God, while the opposite in the New Covenant is a declaration of faith that God *has* been seen. According to legend, the disciple Luke was the first to paint an image of the Holy Mother Mary carrying Christ. In Coptic iconography there are countless parallels between modern treatments of Christ and Saint Mary and very early Christian imagery – even parallels to ancient Egyptian religious symbolism. Perhaps the most obvious are in images of the Flight into Egypt. Mary's sky-blue clothing likens her symbolically to the ancient Egyptian sky goddess Nut, said to give birth to the sun god Ra every morning. This parallels Malachi, where Christ is prophesied to be the "Sun of Righteousness, rising with healing in its wings" (Mal. 4:2).

Icons in the Coptic Church Today

The Coptic Synod doesn't often announce new saints, but even before the twenty-one martyrs, two saints were canonized in 2013: Pope Kyrillos VI and Archdeacon Habib Girgis. These new saints, unlike early Christian saints, were men whom people still living had known personally. Their canonization was a reminder, too, of how the Coptic Orthodox Church had changed during their lifetimes. Once a church

PAINTING AN ICON: THE PROCESS

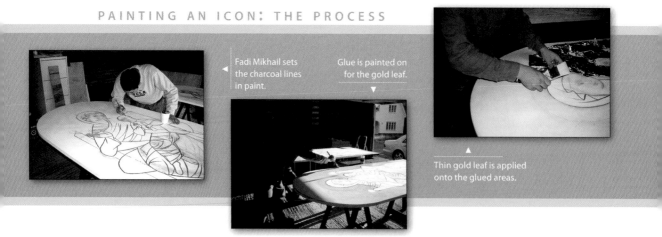

Fadi Mikhail sets the charcoal lines in paint.

Glue is painted on for the gold leaf.

Thin gold leaf is applied onto the glued areas.

whose geographic reach did not extend far beyond Egypt, it is now a growing and thriving family around the world. Dozens of churches are founded every year, particularly in North America.

The new generation of Western-born Copts is under enormous pressure to establish what it means to be a Coptic Christian outside the motherland, and the resulting mix of Western and Eastern influences creates a dichotomy of cultures and tastes that are difficult to reconcile. Chief among these areas of contention is the iconography of the church.

In *Theology of the Icon,* the twentieth-century iconographer and theologian Leonid Ouspensky writes that an icon should be rendered "in the visual language of its time."[2] Yet what, considering the great diaspora of Coptic Christians, is the visual (and cultural) language of our time? Young Coptic iconographers are having a hard time answering this question.

Finding the way forward compels us to look back at how Egypt's rich and ancient artistic history gave rise to today's iconography. Egyptian art has been heavily influenced by visiting or immigrant cultures. Greek influence is evident in the Fayum funerary portraits (circa the first century BC to the third century AD), which show a more naturalistic style infiltrating the abstraction of the earlier Egyptian painters. In the sixteenth to eighteenth centuries, Byzantine characteristics were frequently seen in Coptic iconography. During the 1800s and 1900s, prints of Catholic saints painted in the realism of the Italian Renaissance dominated new iconography in Egypt. Copts had apparently lost almost all knowledge of their earlier, abstract style.

Then in the mid-1960s, Isaac Fanous, an Egyptian Copt and art teacher, sought to rediscover and re-establish an authentic Coptic style. After studying in France at the Louvre and under Ouspensky, Fanous returned to Egypt and developed what is now known as the Neo-Coptic style. This style carefully takes into account the symbolism used by ancient iconographers and values an understanding of early Coptic painting and textiles, but also makes use of cubism and other modern modes of expression.

Fanous's students vary widely in their commitment to his teachings, and a modern Coptic church has at its disposal a range of iconographers whose work runs the gamut from Fanous's Neo-Copticism to the Italian naturalistic style that their grandparents knew in Egypt.

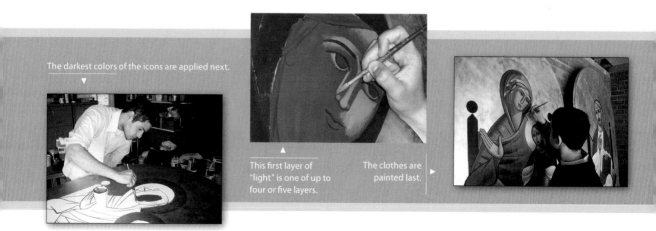

The darkest colors of the icons are applied next.

This first layer of "light" is one of up to four or five layers.

The clothes are painted last.

The photographic record has also had an effect on modern icon style. If an image is rendered too realistically, the iconographer risks inventing personal features and forcing his own subjective interpretation onto the viewer. Thus icons traditionally avoid extremes of facial expression – large smiles, angry scowls, expressive weeping. Therefore, when Coptic iconographers make icons of new saints – whose faces we know from photographs – they strive to abstract the faces to match, as closely as possible, the more geometrically rendered faces of older saints. But some of the most powerful photographs of Saint Pope Kyrillos VI, for example, show him smiling and staring deeply at the camera. I believe that if a saint was known to show great love and compassion in his face, then it is consistent with the spirit of iconography for an icon to express this.

Icons and Technology

Artistic style is not the only determining factor in the appearance of today's icons: cost is always an issue. When a church wants new icons, for example, it can choose to commission an experienced but expensive iconographer living in the West, or to seek an iconographer in Egypt whose prices can be more competitive. Alternatively, churches might employ young icon enthusiasts from within their congregations. Using printed reproductions is even cheaper – but that is not without other costs.

Recently a friend of mine heralded the installation of some icons on the ceiling of his church. These were digital (computer art) images of the four evangelists, "painted" on a digital tablet and printed on canvas. I argued that one of the most beautiful characteristics of the handmade icon is how it offers back to God parts of the different earthly kingdoms

that he gives us. From the animal kingdom we use egg to create egg tempera paint. From the mineral kingdom we use natural pigments. From the vegetable kingdom we use wooden boards. Finally, from the human kingdom we use our own God-given creativity. By replacing these authentic materials with printer ink and plastic, are we reducing the beauty of the icon?

Reprinting existing icons is certainly faster, cheaper, and easier than commissioning new work. Yet at the same time, do we not reduce the beautiful symbolism contained in the artistic process when we create single-layered images using a computer? For the artistic process of handmade iconography is anything but single-layered. It is in itself a parallel of the spiritual journey of the believer. As Monica René, an expert in Coptic culture, writes:

> If an icon is about anything at all, it is firstly about light. The technique of egg tempera can be seen as a metaphor for the ascent of the soul from the darkness of the material plane into the light of the spirit. . . . Symbolically [the application of the dark base layers of an icon] represents our state of blindness to the things of the spirit or separation from the divine, or absence of light. Later, after re-establishing order by redefining the original line drawing, the iconographer begins to apply the light, gradually adding brighter layers. . . . Thus the saint progressively "appears" from the darkness into the Taboric or heavenly light.[3]

Icons and Mission

Whether its creation is a spiritually-rich metaphor or simply the product of an inkjet, the modern icon continues the enlightening work of sacred painting begun in ancient times.

First and foremost an icon is to declare *in images* – just as the gospel does *in words* – that we believe in the incarnation of God the Son. We believe that making an image of Jesus of

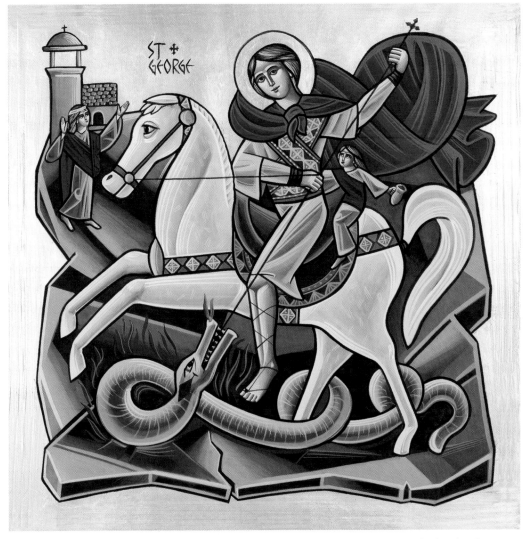

Fadi Mikhail, *Icon of Saint George*, presented by Archbishop Angaelos of the Coptic Orthodox Church to the Prince of Wales in 2013 upon the birth of his grandson Prince George.

Nazareth constitutes a faithful declaration that although he is fully God, he can be portrayed in the flesh, because he took on flesh and we have seen him with our own eyes. Second, an icon must be a visual reminder of the spiritual realm in which we live: a community of living saints who came before us – or who have lived among us – and continue to inspire us to "be holy, as [God] is Holy" (1 Pet. 1:16).

True, images can never replace a person. They are simply windows to look through, inviting us to remember the deeper feelings and devotions that the person brought to light. This is the role of the icon in the Coptic Church today: spreading the Light of the World. ⤳

1. Eusebius, *Ecclesiastical History,* chapter 18.

2. Leonid Ouspensky, *Theology of the Icon* (St. Vladimir's Seminary, 1992).

3. Monica René, "Contemporary Coptic Art," *Coptic Civilisation: Two Thousand Years of Christianity in Egypt* (American University in Cairo, 2014), 279.

Making a Work of Art

JOHN BERGER

Vincent van Gogh, *Wheat Field with Cypresses* (detail)

IT IS NOT SHAMEFUL to cease to be an artist – such an idea only comes from the melancholy of romanticism. When the English painter Hogarth said that he would rather rid London of cruelty than paint the Sistine Chapel, he was making a more than reasonable choice.

Yet those who do remain artists working under their own volition – how do we fight for what we believe? In what way are we militant? The very question would sound absurd to most of my fellow painters in London. We are not militant, they would say: and if they were honest they would add that they paint to make money or to discover something about themselves. Or – most likely of all – just because they enjoy it. Who could object? But let there be no deception. This is not why Delacroix, Géricault, Courbet, Cézanne, Pissarro, van Gogh, Gauguin worked; nor is it why any other major artist of the last two centuries worked. All of these men were militant: militant to the point of being prepared to die for what they believed in. Delacroix believed in what he called "the beautiful"; Cézanne in his petite sensation; van Gogh in his "Humanity, humanity, and again humanity." They fought for their various visions and most of their militant energy was concerned with fighting the difficulties of realizing their vision, of finding the visual forms that would turn their hunches into facts. Each of their different visions, however, sprang from the same kind of conviction; they each knew that life could be better, richer, juster, truer than it was. Every modern attempt to create a work of art is based on the desire (usually undeclared) to increase the value of the experience that gave rise to the work.

IF WE THINK of ourselves as special creators, we are wrong. Everyone creates in the same way we do. They invent, imagine, hope, dream, frighten themselves, remember, observe – and from all this they make for themselves certain ideas and images, some expressible, some inexpressible. Where we're different from most people is the way we try to destroy these ideas and images. We hit at them, strike them, do our utmost to kill them. We often succeed – the image falls away, lifeless, at last recognizable as a lie or cliché. Just occasionally there is one that withstands our beating. It won't die. The more we beat it, the stronger and harder it becomes. It becomes indestructible. We have made a work of art. ⌁

John Berger (1926–2017) was an English art critic, novelist, painter, and poet. This reading is taken from his novel A Painter of Our Times *(Vintage, 1989).*

The Business of the Artist

DOROTHY L. SAYERS

From a letter:

PUBLIC ENEMY NO. 1 – if you must use these expressions – is a flabby and sentimental theology which necessarily produces flabby and sentimental religious art. The first business for church officials and churchmen is, I think, to look to their own mote and preach and teach better theology. But the point which they do not recognize is this: that for any work of art to be acceptable to God it must first be right with itself. That is to say, the artist must serve God in the technique of his craft; for example, a good religious play must first and foremost be a good play before it can begin to be good religion. Similarly, actors for religious films and plays should be chosen for their good acting and not chosen for their Christian sentiment or moral worth regardless of whether they are good actors or not. (A notorious case to the contrary is the religious film society which chose its photographers for their piety, with the result that a great number of the films were quite blasphemously incompetent.) The practice, very common among pious officials, of asking writers to produce stories and plays to illustrate a certain doctrine or church activities shows how curiously little these good people as a class understand the way in which the mind of the writer works. The result in practice is that instead of the doctrines springing naturally out of the action of the narrative, the action and characters are distorted for the sake of the doctrine, with disastrous results.

This is what I mean when I ask that the church should use a decent humility before the artist, whose calling is as direct as that of the priest, and whose business it is to serve God in his own technique and not in somebody else's. Matters are only made worse when Sunday Observance Societies and other groups talk wildly about modern tendencies in art and so bring the church into contempt, not only for bigotry but also for ignorance.

I quite agree that a great deal of ecclesiastical bric-à-brac needs purging. It is, as you say, so difficult to choose the really sound authorities to pronounce on the artistic merit of hymns and so forth. I believe that here again the soundest method is to purge at once the works which express a sickly brand of religious sentiment. . . . It is very noticeable how well the great mediæval hymns stand up to the test of time and the test of translation, on account of the soundness of the theology which inspired them.

From a lecture:

THE TRUE WORK OF ART, then, is something *new* – it is not primarily the copy or representation of anything. It may involve representation, but that is not what makes it a work of art. It is not manufactured

Raphael, *Saint Michael* (detail)

Raphael,
Saint Michael
(detail)

to specification, as an engineer works to a plan – though it may involve compliance with the accepted rules for dramatic presentation, and may also contain verbal "effects" which can be mechanically accounted for. We know very well, when we compare it with so-called works of art which are "turned out to pattern," that in this connection "neither circumcision availeth anything nor uncircumcision, but a new creature" [Gal. 6:15]. Something has been created.

THIS RECOGNITION of the truth that we get in the artist's work comes to us as a revelation of new truth. I want to be clear about that. I am not referring to the sort of patronising recognition we give to a writer by nodding our heads and observing: "Yes, yes, very good, very true – that's just what I'm always saying." I mean the recognition of a truth which tells us something about ourselves that we had *not* been "always saying" – something which puts a new knowledge of ourselves within our grasp. It is new, startling, and perhaps shattering – and yet it comes to us with a sense of familiarity. We did not know it before, but the moment the poet has shown it to us, we know that, somehow or other, we had always really known it.

Very well. But, frankly, is that the sort of thing the average British citizen gets, or expects to get, when he goes to the theatre or reads a book? No, it is not. In the majority of cases, it is not in the least what he expects, or what he wants. What he looks for is not this creative and Christian kind of art at all. He does not expect or desire to be upset by sudden revelations about himself and the universe. Like the people of Plato's decadent Athens, he has forgotten or repudiated the religious origins of all art. He wants entertainment, or, if he is a little more serious-minded, he wants something with a moral, or to have some spell or incantation put on him to instigate him to virtuous action.

Now, entertainment and moral spell-binding have their uses, but they are not art in the proper sense. They may be the incidental effects of good art; but they may also be the very aim and essence of false art. And if we continue to demand of the arts only these two things, we shall starve and silence the true artist and encourage in his place the false artist, who may become a very sinister force indeed.

HE GREAT THING, I am sure, is not to be nervous about God – not to try and shut out the Lord Immanuel from any sphere of truth. Art is not He – we must not substitute art for God; yet this also is He, for it is one of His images and therefore reveals His nature. Here we see in a mirror darkly – we behold only the images; elsewhere we shall see face to face, in the place where image and reality are one. ⤳

These selections from the British novelist Dorothy L. Sayers (1893–1957) are taken from a new collection of her writings The Gospel in Dorothy L. Sayers *(Plough, 2018)* plough.com/sayers

The Creative Process

JAMES BALDWIN

ERHAPS THE PRIMARY distinction of the artist is that he must actively cultivate that state which most men, necessarily, must avoid: the state of being alone. That all men are, when the chips are down, alone, is a banality – a banality because it is very frequently stated, but very rarely, on the evidence, believed. Most of us are not compelled to linger with the knowledge of our aloneness, for it is a knowledge that can paralyze all action in this world. There are, forever, swamps to be drained, cities to be created, mines to be exploited, children to be fed. None of these things can be done alone. But the conquest of the physical world is not man's only duty. He is also enjoined to conquer the great wilderness of himself. The precise role of the artist, then, is to illuminate that darkness, blaze roads through that vast forest, so that we will not, in all our doing, lose sight of its purpose, which is, after all, to make the world a more human dwelling place.

The state of being alone is not meant to bring to mind merely a rustic musing beside some silver lake. The aloneness of which I speak is much more like the aloneness of birth or death. It is like the fearless alone that one sees in the eyes of someone who is suffering, whom we cannot help. Or it is like the aloneness of love, the force and mystery that so many have extolled and so many have cursed, but which no one has ever understood or ever really been able to control. I put the matter this way, not out of any desire to create pity for the artist – God forbid! – but to suggest how nearly, after all, is his state the state of everyone, and in an attempt to make vivid his endeavor. The state of birth, suffering, love, and death are extreme states – extreme, universal, and inescapable. We all know this, but we would rather not know it. The artist is present to correct the delusions to which we fall prey in our attempts to avoid this knowledge. . . .

I seem to be making extremely grandiloquent claims for a breed of men and women historically despised while living and acclaimed when safely dead. But, in a way, the belated honor that all societies tender their artists proves the reality of the point I am trying to make. I am really trying to make clear the nature of the artist's responsibility to his society. The peculiar nature of this responsibility is that he must never cease warring with it, for its sake and for his own. Societies never know it, but the war of an artist with his society is a lover's war, and he does, at his best, what lovers do, which is to reveal the beloved to himself and, with that revelation, to make freedom real. ⤳

Aaron Douglas, *Song of the Towers* (detail)

Source: *James Baldwin: Collected Essays* (Library of America, 1998). Used by arrangement with the James Baldwin Estate. © Estate of James Baldwin.

James Baldwin (1924–1987) was an American novelist and public intellectual.

Return to Appalachia

Why two young women went to Ohio to teach children art in a barn

SUSANNAH BLACK

IN NOVEMBER 2016 Hillary Wagner and Francesca Fiore were beginning their last year at Parsons School of Design in New York City. Although they had been following national politics, it was a local issue that captured Hillary on the day of the election: the school arts program in her rural Appalachian hometown was in danger of having its funding cut.

"I was horrified by this prospect," she says, "recalling how already scant my opportunities had been as a creative child growing up in Bethel, Ohio. I cried a puddle on Francesca's studio floor on the day of the election."

But later, in a diner off Union Square in lower Manhattan, the two women began to get an idea, fueled by their knowledge of art, community building, and political activism: to start a community arts program that would serve the town's children and help reconnect those kids to their local history and agricultural roots. Sadness and anger turned to excited planning as they decided that they, with Francesca's husband, Matthew Kosinski, should move to Bethel immediately after graduation. In the spring of 2017, with two freshly-minted MFAs, they did.

Bethel, Ohio, faces formidable problems. Many area families live in poverty, struggling

Susannah Black is a contributing editor to Plough *and has written for publications including* First Things, Fare Forward, Front Porch Republic, Mere Orthodoxy, *and* The American Conservative. *She lives in New York City.*

Friends and neighbors visit the Barn Studio during an exhibition, 2017.

But, as was the case with so many families in the area, with the death of her great grandfather in 2003, her family's farming tradition died as well: "I have spent much of my life consciously or unconsciously trying to reconnect with that tradition of love and a deep, intimate knowledge of the land and its creatures. . . . I have only recently begun to truly understand and thus value my Appalachian identity."

When Hillary was growing up in Bethel she saw a great deal of community strength, some of which is still present. But despite this, times got harder; she "saw businesses in the town struggle and fail so often it felt normal." She heard her parents, public school teachers, talk about the increasing percentage of students on free and reduced lunch, and the ever-looming threat of cuts and failed emergency operating levies. Returning to Bethel meant facing high poverty and unemployment rates, but it also meant seeing the burgeoning local efforts to meet those needs.

Scott and Lori Conley's Bethel-based organization, Empower Youth, attempts to help kids break out of generational poverty. Each Friday they provide bags of food so over six hundred students will have enough for the weekend. The Conley's program also helps students plan and pursue their own goals, supporting them through high school graduation, encouraging them to apply to college, and helping them get work experience. During the summer of 2017 Francesca, Matthew, and Hillary enlisted a group of Empower Youth's teenage interns. Together they rehabbed an old barn on the Empower Youth Ranch into a studio space.

The goal was to create space for the art lessons that Francesca and Hillary were busy preparing. Working on the space itself, however, became a crucial part of their relationship with the community, Hillary says: "As

to afford groceries. Feeling little connection to their town and its history, young people are eager to leave. Francesca and Hillary were convinced that an arts program could push back against some of these problems to draw together a fragmented community. They called the project *SOIL SERIES,* aiming to help preserve the town's links to its agricultural past.

Most locals don't make a living from agriculture anymore, but a few generations ago the land was home to many subsistence farmers. This history, Hillary says, reached forward into her own life. "When I was a little girl my great grandparents were still operating their small dairy farm, and I loved helping them with the milking and the garden. My earliest memory (I was probably two or three) is of my grandfather setting me up high on the back of a Holstein bull."

Empower Youth interns and volunteers renovate the Barn Studio, 2017.

Opposite: Pinch pots made by young artists with clay sourced from a creek at the Ranch, 2017

we guided the students through the renovation of the Barn Studio, they opened up to us, sharing about their lives while painting walls and patching concrete floors. Many came from troubled, complex homes. Many had difficulty imagining hopeful futures. As their struggles became known to us, we worked intentionally to introduce new ideas about politics and culture, art and life. We tried our best to be courageous in our own personal circumstances in order to be examples to them for how to be gracious in strife and strong to overcome obstacles."

Once the Barn Studio was finished the lessons began. Children in the group range from ages five to thirteen. The program has been so successful that they can't accept more children into it.

Now in their second summer with *SOIL SERIES*, Hillary, Francesca, and Matthew must juggle designing and running this project with the very real challenge of affording it. Hillary and Francesca write grant applications and pursue other potential sources of funding while Matthew works remotely. During the year Hillary substituted in the local school. This summer she's been working at Home Depot to help them stay afloat, and she's lined up several adjunct classes to teach at Northern Kentucky University starting in the new school year. People from the community have contributed donations and art supplies.

The Conleys see the value that Hillary, Matt, and Francesca are bringing. In their words, "This is the opportunity for the students of Appalachia to experience art beyond a Vacation Bible School salt dough project or more formal art taught in their schools. Hillary, Francesca, and Matt made art personal . . . and relatable. Their work with the students was secondary only to the impact they made on the older interns who built relationships with them."

This second summer Hillary and Francesca have focused on artists within the Bethel community. One woman spins her alpacas' fleece into yarn, crochets, and weaves – thus, a series on textiles that allows students to try weaving. A member of a local family's bluegrass

band has performed at the Grand Ole Opry; students have learned about the distinctive musical heritage of Appalachia and have made their own instruments. The goal, Hillary says, is for students to "recognize their home as a place where people are already being creative."

Through these community members Hillary and Francesca's vision of weaving agriculture into the program is also coming to pass. They've discovered that although agriculture no longer sustains local families, many still have small-scale farms. "We went to Daniel because he was a musician," Hillary says, "but he also has a farm. We went to Erica because she does textiles, but she also has a farm. Seems like everybody, alongside what they're doing, has a farm."

SOIL SERIES is reminiscent in ways of the Foxfire project of the 1960s, in which a teacher helped his Appalachian students record (and learn) the skills, lore, and practices of their elders. But the issues that today's Appalachian youth face are decidedly contemporary. Students have shared stories of "being out in public and seeing somebody overdose, like at the gas station," says Francesca;" It's just the atmosphere we live in." Against challenges like this, can art classes for kids really make a difference? Francesca and Hillary are convinced they can. One student's mother reported that before he started coming to the studio, he would vomit in school every day from anxiety. Since he's begun art classes he no longer does. And they are making a difference for the young adults as well. Francesca and Hillary told the young people about the intersection of politics and the arts in earlier decades: ACT UP's response to the AIDS crisis, The Guerilla Girls' artistic challenge to sexism and racism. Inspired, the students formed an art collective. They're high schoolers and recent graduates. One nineteen-year-old is

"*Given the opportunity to think differently about themselves and about art, these kids have just transformed.*"

Hillary Wagner

Hillary Wagner working with young artists, 2017

Opposite: Drawing made on a concrete slab with materials found around the Ranch, 2017

working a construction job. He'd been helping out at Empower Youth, hauling boxes. When work began on the barn renovation he pitched in, and when the studio was done, he stayed around to make art. Since then he's beginning to relate his art in the studio with the industrial pipe work at his job. Maybe one day he'll have a sculpture practice.

The art collective has been working on projects closely tied to Bethel's history. They've done research on the town as a stop on the Underground Railroad. They've combed the historical society for photographs and articles to incorporate into collages. They even created an image for a billboard on the main road through town. They spend hours and days together, always making something. According to Hillary, the art collective is the program's greatest success. "These kids have just transformed, given the opportunity to think differently about themselves, about Bethel, and about art. And I think it's because we love each other. We're like family. And the space is their own: it's not within school, it's not within church, it's something else, and the kids are designing it for themselves."

Though it's not within church, for Hillary, this work is a kind of worship. Her Christian faith drives what she hopes to do in Bethel and serves as a bridge to others in the community. She and Francesca see that reknit community as the real work of art they are trying to make. They call it a "social drawing," a version of the "social sculpture" of 1970s expressionist artist Joseph Beuys. Beuys thought of all society as a work of art. Francesca and Hillary are convinced the same is true of this Appalachian town. The art that the community is making, Matthew writes, exists as linkages between people: "God, according to Hillary's belief, is also there in the linkages – the very linkages that give *SOIL SERIES* its transformative capacity. In this way, Hillary's faith helps guide both the social drawing's form and the ends to which it aspires."

Hillary grew up in the church; four generations of her family have been in the Nazarenes, a denomination devoted to missions. "I was

always a part of service projects; it's second nature." For a long time, that seemed to be in tension with her love of art-making. "I couldn't get away from making things," she said. "I thought that to be an artist I had to live this solitary existence, but I loved being with people."

One way do this, she finds, is to spend her Sunday afternoons making art with teenagers. "It's hard to describe exactly the way this house feels when all the kids are here. . . . It's weird just how much joy there is – the way this has transformed the kids, and the changes we see in them – we're in awe. We had these theories about what could happen, but the actual experience of it – it's that glimpse of heaven, that momentary thing."

All of the collaborators on the project, Christian or not, are sowing hope, attempting to plant good seeds in Bethel. Matthew and Francesca are atheists, and their East Coast Catholic upbringings were culturally distant from the low-church Protestantism that is common in Bethel, yet Matthew sees the impact of faith in the work they do. "People who believe in God seem to have easier access to the sublime in their everyday lives, which would be fair to say about many of the people I've met in Bethel. They feel God coursing through unlikely places. . . . That feeling of God turns to an energizing awe, and that energizing awe transforms a dilapidated foreclosed ranch into a communal hub of social, intellectual, artistic, spiritual, and literal nourishment."

Hillary and Francesca's vision to help Bethel's young people seems gradually to be coming true. "Our hope," they say, "is that these students will know that they are capable of achievement because they are from Appalachia, not in spite of it." ➤

> *"I think it works because we love each other. We're like family."*
>
> Hillary Wagner

Alex Nwokolo,
Fragmented Hope,
collage on canvas,
2009

reenter

I did not reenter
As if absent from life and the living
As if I was not just up the road
Off the highway exits you know so well
On the other end of a collect call
Unaccepted
Watching the same news as you
Commercials tempting me with the same food as you
As if I wasn't a part of the perpetual pull
Swinging through the same moods as you
I did not reenter as if
Absent from the living, the taking and giving
Partaking in this thing that marks the existing
The spark and persisting of a heart thought missing
I did not reenter as if absent
From you
As if separated by something more solid than
Societal constructs
As if these walls and such are not just
Aggregate dust
I did NOT reenter
I did not leave just became easy to overlook
Easy to forget
Waiting for the chance to see you
So you could remember that
I never left

COZINE WELCH JR.

MANDELA AND THE GENERAL

JOHN CARLIN, ARTWORK BY **ORIOL MALET**

NELSON MANDELA, who would have turned one hundred this year, led one of history's most powerful nonviolent movements to victory. But as the first post-apartheid elections approached in 1994, the democratic struggle threatened to spiral into an all-out race war, with well-armed white militias ready to fight to the death to stop black rule. Their leader was General Constand Viljoen, retired chief of South Africa's military. Mandela knew he couldn't avert a bloodbath on his own; somehow he would have to win over his archenemy. As they met secretly during those tense months, the mettle of these two men would determine the future of a nation.

As foreign correspondent for the *Independent* of London, John Carlin had a front-row seat as the drama unfolded, with access to leaders on both sides. This excerpt from *Plough*'s forthcoming graphic novel *Mandela and the General* opens with Carlin interviewing General Viljoen at a Cape Town bar several years later.

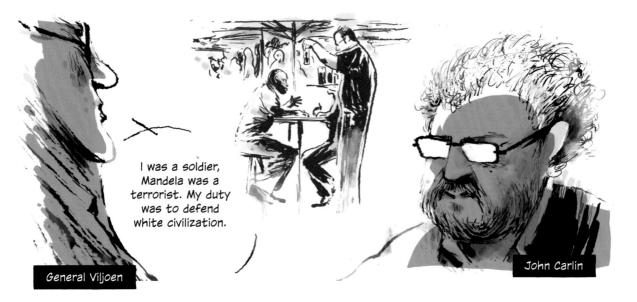

I was a soldier, Mandela was a terrorist. My duty was to defend white civilization.

General Viljoen

John Carlin

"Things were so different when I was a young, up-and-coming soldier. I'll never forget one sunny winter's day in 1964 when I got leave from the army to travel to the family farm. It brings back such vivid memories."

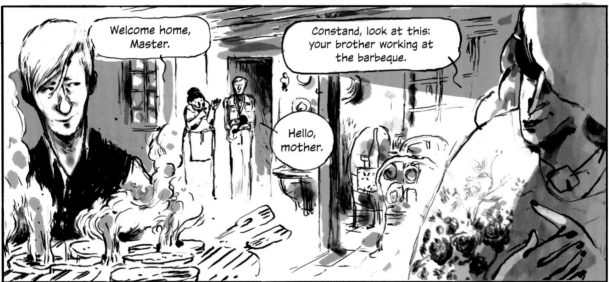

Welcome home, Master.

Constand, look at this: your brother working at the barbeque.

Hello, mother.

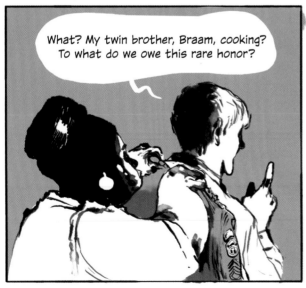

What? My twin brother, Braam, cooking? To what do we owe this rare honor?

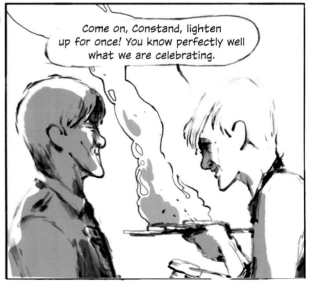

Come on, Constand, lighten up for once! You know perfectly well what we are celebrating.

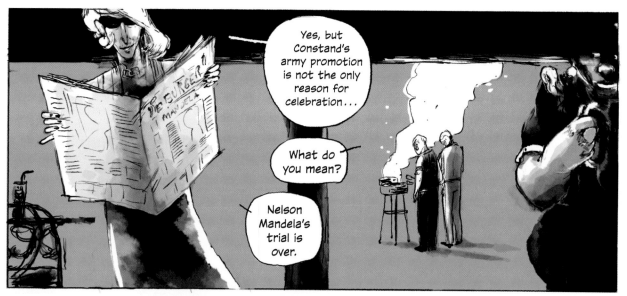

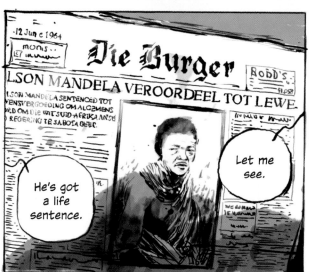

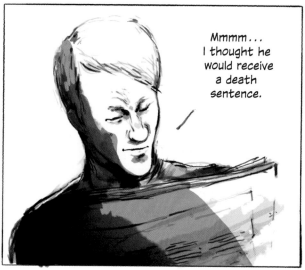

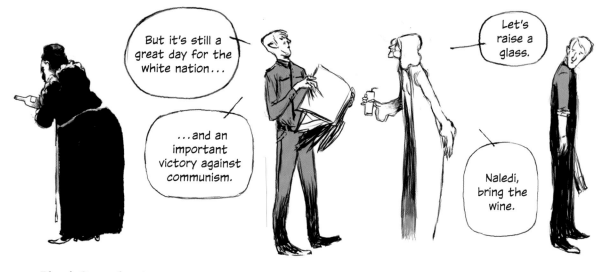

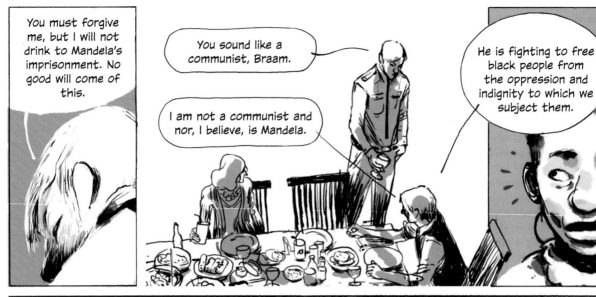

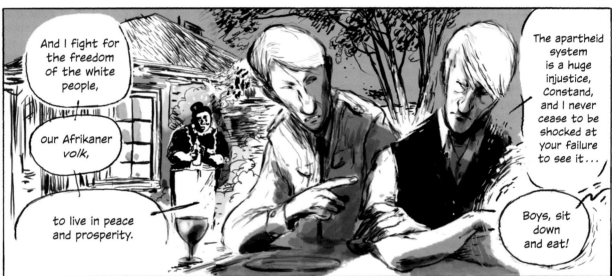

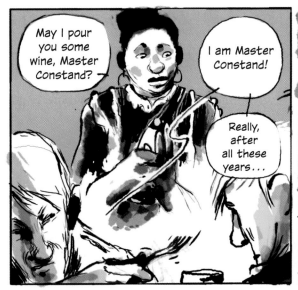

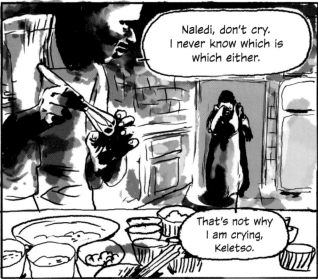

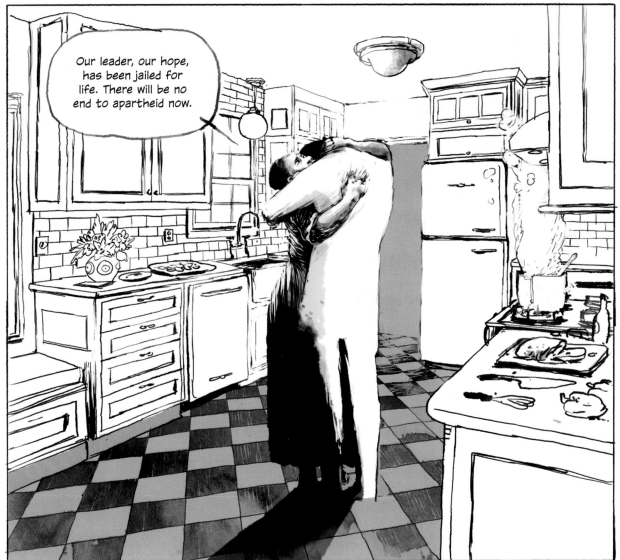

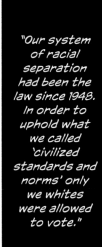

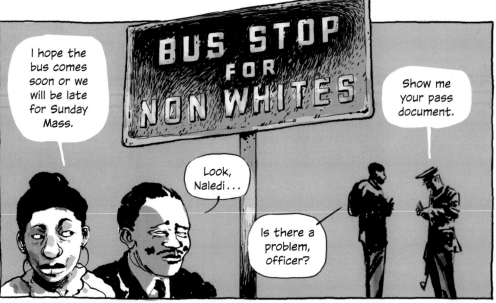

I hope the bus comes soon or we will be late for Sunday Mass.

BUS STOP FOR NON WHITES

Show me your pass document.

Look, Naledi . . .

Is there a problem, officer?

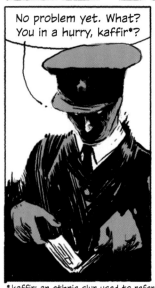

No problem yet. What? You in a hurry, kaffir*?

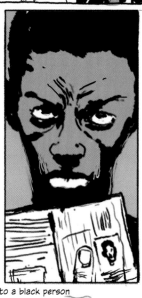

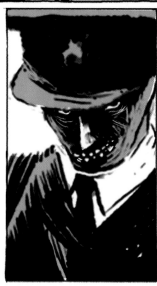

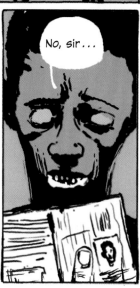

No, sir . . .

*kaffir: an ethnic slur used to refer to a black person

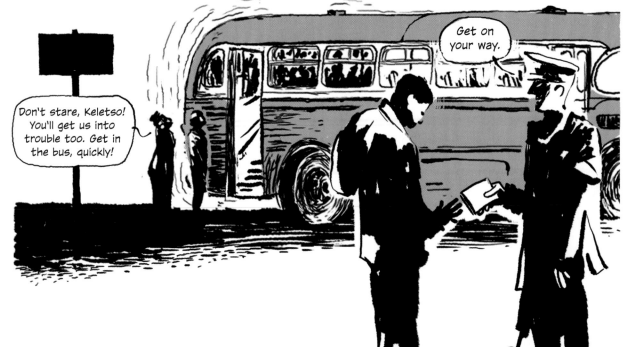

Don't stare, Keletso! You'll get us into trouble too. Get in the bus, quickly!

Get on your way.

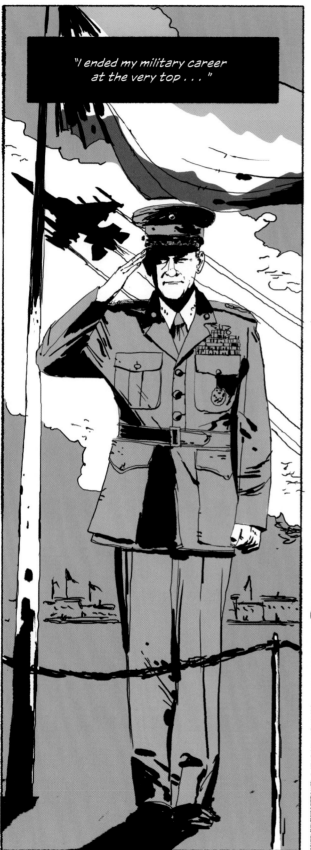

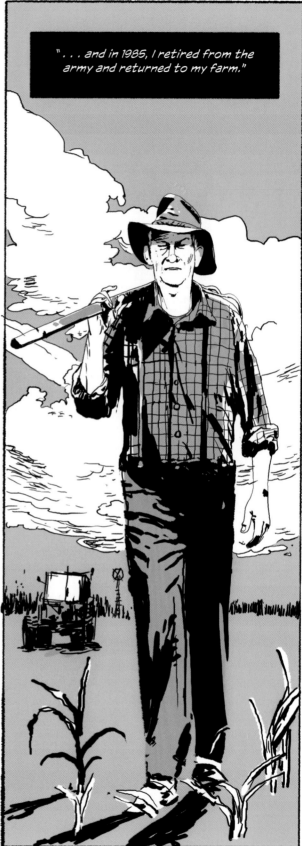

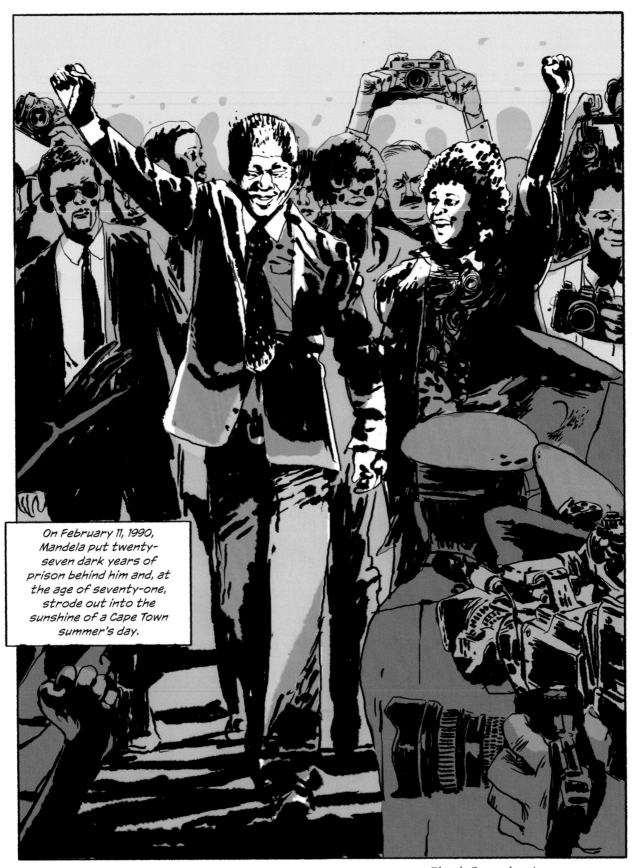

On February 11, 1990, Mandela put twenty-seven dark years of prison behind him and, at the age of seventy-one, strode out into the sunshine of a Cape Town summer's day.

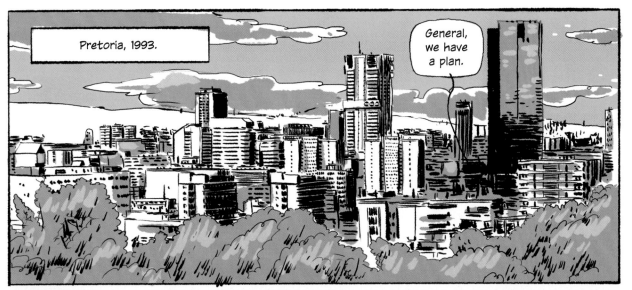

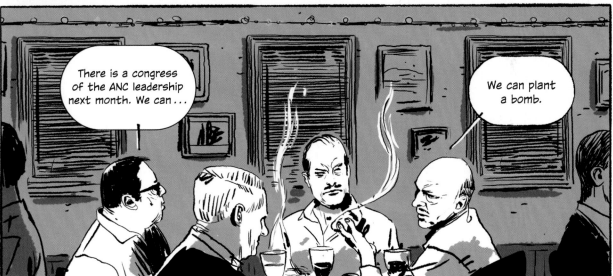

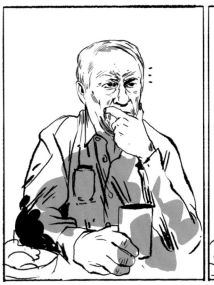

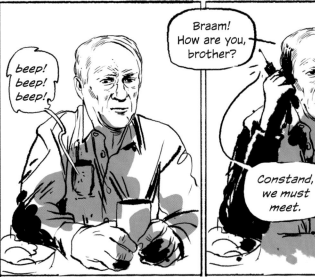

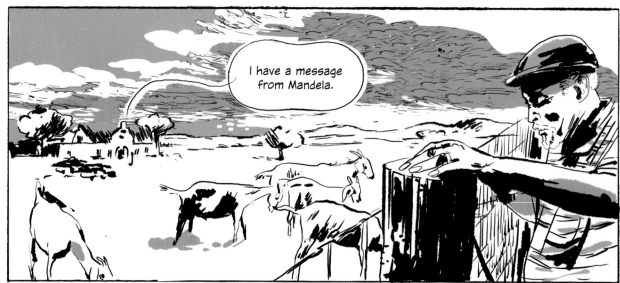

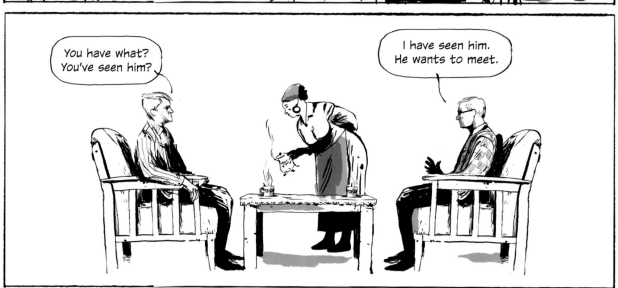

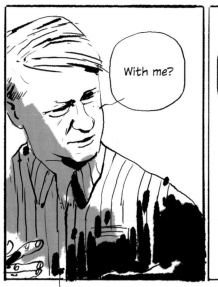

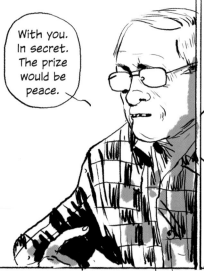

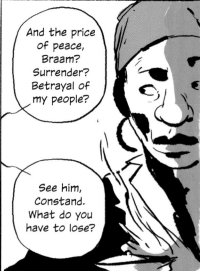

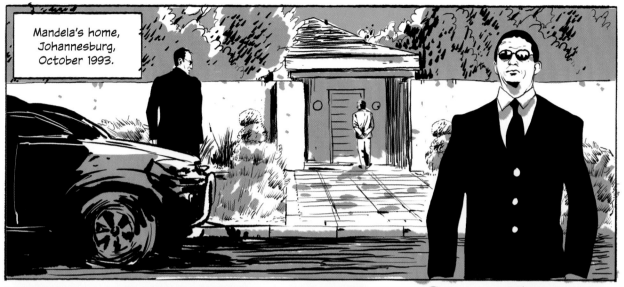

Mandela's home,
Johannesburg,
October 1993.

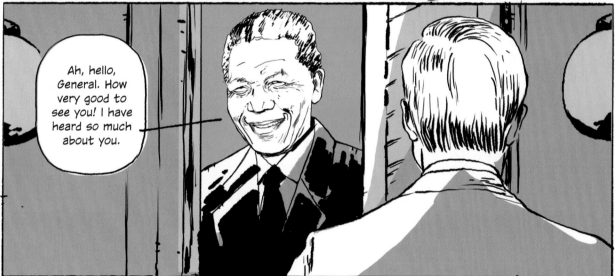

Ah, hello,
General. How
very good to
see you! I have
heard so much
about you.

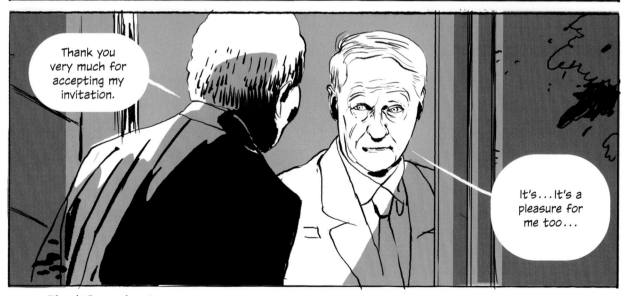

Thank you
very much for
accepting my
invitation.

It's...It's a
pleasure for
me too...

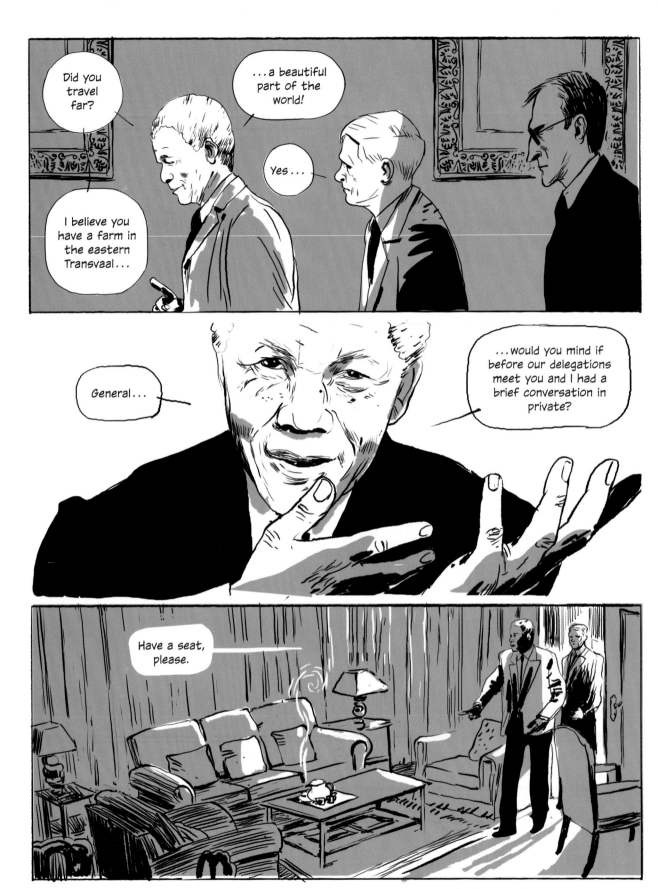

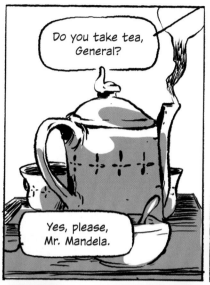

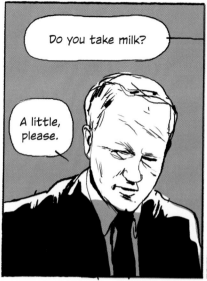

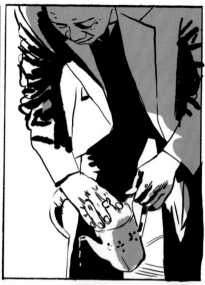

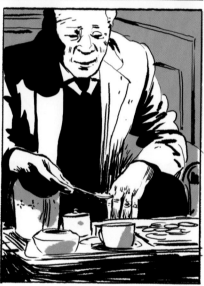

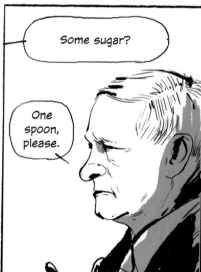

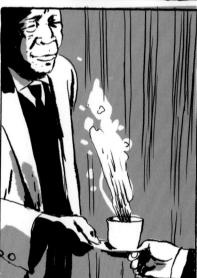

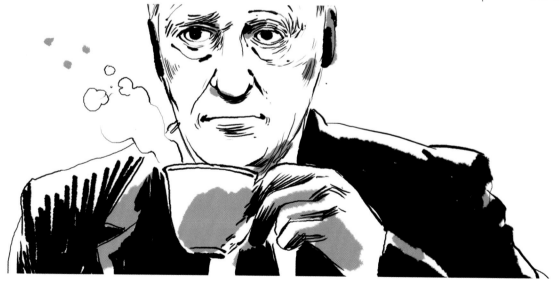

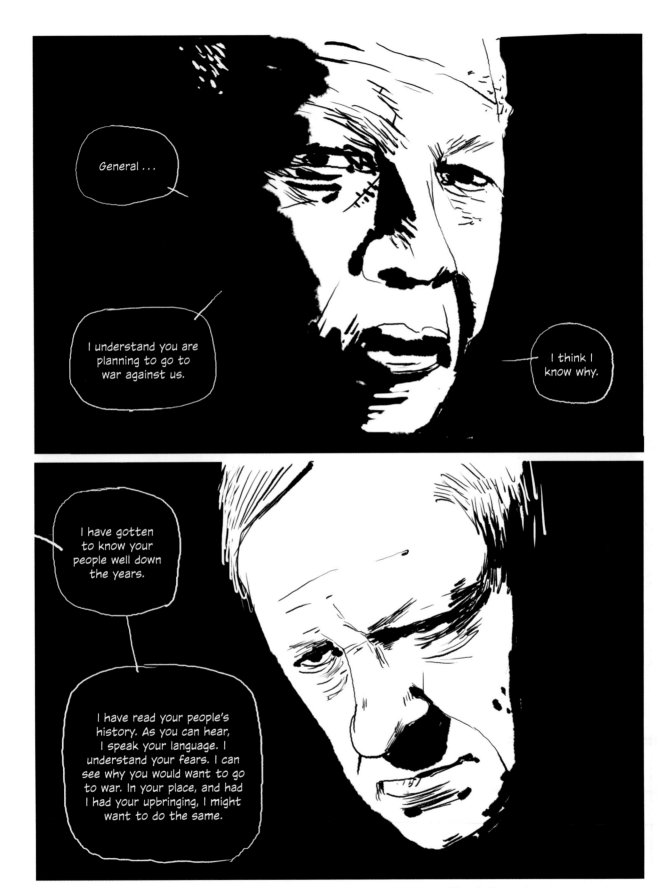

And, General, I know too that you have the guns and the manpower to cause terrible bloodshed in this country. You are stronger militarily than us, but we have the numbers. And we will have the international support.

I put it to you, General, that if you go to war as you propose, all we will end up with will be the peace of cemeteries. Would you agree?

Mr. Mandela, in all honesty I cannot disagree with your analysis. And I have to say that I know what war is and I know what it is to speak to the widows and mothers of dead soldiers.

We will now go and talk with our people, whom we have kept waiting too long. But I believe this must not be the last private conversation that you and I have.

I believe we must carry on meeting, discreetly, to see if we can find a way that will reconcile your people's understandable fears with my people's legitimate aspirations.

Agreed, Mr. Mandela. We must try at least.

Let us shake hands on this, General. Peace must be our goal. Peaceful coexistence between your people and mine.

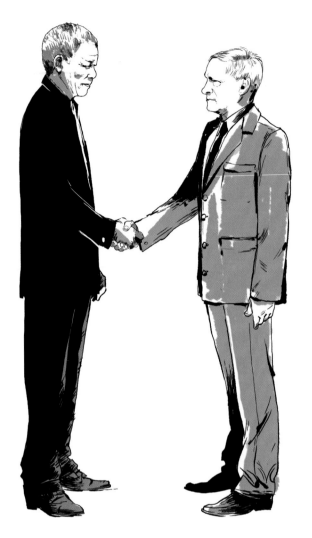

Mandela and the General
John Carlin, Oriol Malet

"A riveting read. Carlin 'gets' Mandela. He captures powerfully
Mandela's political astuteness and vast generosity. Masterful
storytelling!" **Morgan Freeman**

"A fascinating story with a tight focus." **Kirkus Reviews**

"A wonderful, accessible distillation of the genius of Mandela. In
an increasingly divided political landscape, should be required
reading for people of all ages everywhere." **Matt Damon**

"A timely reminder of the value of human empathy as a tool in
political confrontation." **Jon Lee Anderson**, author of *Che*

softcover
112 pages
Plough, 2018

plough.com/mandela

WHY
WE LIVE IN
COMMUNITY

EBERHARD ARNOLD

A Manifesto

Socialism, or at least talk of it, is resurgent. What explains the
widespread new openness to a radical solution to age-old
ills – economic exploitation, political injustice, and simple
loneliness? One reason, surely, is that the liberal capitalism of
recent decades has forgotten to ask the fundamental questions
about how we are to live: questions about justice, freedom, the
good life, and community.

The essay that follows is, according to the Trappist writer
Thomas Merton, a "completely Christian answer" to such
questions. Writing in 1925, Eberhard Arnold describes an
alternative to both Marxist socialism and identity-based
nationalism – a vision drawn not only from his theological
study but also from his experience of communal life. His
manifesto appears here in a new complete translation.

Life in community –

living and working together – is nothing less than a necessity for us. It is an inescapable "must" that determines everything we do and think.

Our own plans and efforts are not what have been decisive for us in choosing to live this way. Rather, we have been gripped by a certainty – a certainty that has its origin and power in the source of every necessity, a source able to transform all compulsion. This source takes anything that seems a necessity and overwhelms it with superior power. We confess: this source, this power, is God.

Eberhard Arnold (1883–1935), a German writer and theologian, was Plough's *founding editor as well as a founder of the Bruderhof communities.*

Faith and Community

God is the source of life. In him and through him our common life is built up and led time and again through acute struggles to ultimate victory. In such a life, one will seek in vain for a pleasant idyll of human comfort or the fulfillment of romantic yearnings; much less will this life satisfy any egoistic desires for personal happiness. No, this is a way dedicated to the unconditional will to love, a way that shares in God's own will to community. It is an exceedingly dangerous way, a way of deep suffering, which leads straight into the struggle for existence and a life of labor, into all the difficulties created by the human character. And yet, just this is our deepest joy: to see clearly the momentous conflict – the indescribable tension between life and death, man's position between heaven and hell – and still to believe that life, love, and truth will triumph over all opposition, because we believe in God.

This faith is not a theory for us; neither is it a dogma, a system of ideas, a fabric of words, or a form of worship, nor is it an organization such as a church or sect. Faith means receiving God himself – it means being overwhelmed by God. Faith is the strength that enables us to take this path. It helps us to find trust again and again when, from a human point of view, the foundations of trust have been destroyed. Faith gives us the vision to perceive what is essential and undying. It gives us eyes to see what cannot be seen, and hands to grasp what cannot be touched, although this intangible reality is present always and everywhere.

Faith gives us the ability to see people as they are, not as they present themselves. It frees us from viewing others in the light of social custom or according to their weaknesses. It cannot be deceived by the masks of good manners and convention, of business respectability, of middle-class morals, of pious observance, or of political power. For faith sees that all these masks, fashioned as they are by our Mammon-worshiping, unclean, and murderous society, amount to a lie.

Yet neither will faith be deceived in the other direction and made to think that the maliciousness and fickleness of the human character (though real) are its actual and ultimate nature. To be sure, faith takes seriously the fact that we human beings, with our present natural makeup, are incapable of community. Temperamental mood-swings, possessive impulses and cravings for physical and emotional satisfaction, powerful currents of ambition and touchiness, the desire for personal influence over others,

and human privileges of all kinds – all these place seemingly insurmountable obstacles in the way of true community.

But with faith we cannot be deluded into thinking that these real weaknesses of human nature are decisive. On the contrary, in the face of the power of God and his all-conquering love, they are of no significance. God is stronger than these realities. The community-creating energy of his Spirit overcomes them all.

Here it becomes abundantly clear that the realization of true community, the actual building up of a communal life, is impossible without faith in a higher Power. In spite of all that goes wrong, people try again and again to put their trust either in human good-ness (which really does exist) or in the force of law. But all their efforts are bound to come to grief when faced with the reality of evil. The only power that can build true community is faith in the ultimate mystery of the Good: faith in God.

Social Justice and Community

With this faith, we must take a firm stance in relation to public questions of international, political, social, and economic life. There are political organizations that stand, as we do, for international peace, the abolition of private property, and full community of goods. Yet we cannot simply side with these organizations and fight their battles in their way. These political movements may aim to achieve a broad public good, but because of the way they fight, they end up being anti-communal: they are unable to bring about the common welfare of all in a community that includes all. Despite their abundant good intentions, they lack the strength and capacity to replace an exhausted society with an organic, living community. As the history of all such movements attests, they cannot overcome humankind's covetous desire to possess.

All the same, we do feel drawn, with these movements, to all people who suffer need and distress, to those who lack food and shelter and whose very mental development is stunted through exploitation. With them, we stand side by side with the have-nots, with those deprived of their rights, and with the degraded and oppressed. And yet we avoid the kind of class struggle that employs loveless means to exact vengeance on those who have exploited the workers to the very blood. We reject the defensive war of the oppressed proletariat just as much as the defensive wars of nations – even though we are committed to the freedom of our nation and to the freedom of the working class around the world. Both are enslaved, and we know that this slavery must end. But the fight that we take up against it is one

True community is impossible without faith in a higher power.

69

fought spiritually. This is a struggle in which we stand on the side of all those who fight for freedom, unity, peace, and social justice.

It is precisely for this reason that we must live in community. All revolutions, all communes, all idealistic or reform-oriented movements show simultaneously their yearning for community and their incapacity for it. These examples force us to recognize again and again that there is only one way to bring into living reality the desire for community that lies hidden at the heart of all revolutions: through the clear example of action born of truth, when both action and word are one in God.

We thus have the only weapon that can be effective against the depravity that exists today. This weapon of the Spirit is constructive work carried out in a fellowship of love. We do not acknowledge sentimental love, love without work. Nor do we acknowledge dedication to practical work if it does not daily give proof of a heart-to-heart relationship between those who work together, a relationship that comes from the Spirit. The love of work, like the work of love, belongs to and comes from the Spirit.

Community through Church History

This Spirit-filled life of practical love was attested in a decisive way by the Jewish prophets and later by the first Christians. We acknowledge Christ, the historical Jesus whose mother was Mary and who was executed under the Roman governor Pontius Pilate. We acknowledge, too, his entire message as proclaimed by his apostles and practiced by his first followers as they lived in full community [as is recorded in Acts 2 and 4].

Therefore we stand as brothers and sisters with all those who, moved by the Spirit, have joined together to live in community through the long course of history. They appeared at many times:

Among the Christians of the first century;

In the prophetic movement of the Montanists in the second;

In the monastic movements of the following centuries;

In the revolutionary movement of justice and love led by Arnold of Brescia;[1]

In the Waldensian movement;

In the itinerant communities of Francis of Assisi;

1. Arnold of Brescia (1090–1155) was an Italian priest and monk who protested an over-powerful clergy and argued that the church should renounce its property and live in "apostolic poverty." He was excommunicated and eventually executed on the orders of the Roman Curia. —Ed.

2. The Brothers of the Common Life, a monastic order that existed from the end of the fourteenth century until the Reformation, lived by the work of their hands, especially by copying. Their best-known member was Thomas à Kempis (1380–1471), author of The Imitation of Christ. —Ed.

We do not acknowledge sentimental love: love without work.

Among the Bohemian and Moravian Brethren and the Brothers of the Common Life;[2]

Among the Beguines and Beghards;

In a special way among the first Anabaptist movements of the sixteenth century, known for their brotherly communism, nonviolence, and the agricultural and craft work of their Bruderhof settlements;

Among the early Quakers;

Among the Labadists of the seventeenth and eighteenth centuries;[3]

Among the early Moravians around Zinzendorf;

And in many other Christ-centered communities of diverse denominations down to our present day.

We commit ourselves to Jesus and to the form of life of early Christianity, because here people's outward needs were helped as well as their inner ones. Here the body and the earth were never held in contempt, yet at the same time the soul and spirit were also cared for. When people asked Jesus what God's future justice would look like, he pointed to his actions: sick bodies were healed, the dead in their graves were raised up, demons were driven out of tormented bodies, and the message of joy was brought to the poorest of the poor. This message means that the invisible kingdom of the future now is near, and indeed is becoming reality – God is becoming man, God is becoming flesh, and at last the earth will be won for him, whole and entire.

It is the whole that matters here. The love of God does not acknowledge any border or stop at any barrier. Therefore, Jesus does not stop in the face of private property any more than he does in the face of theology, moralism, or the State. Jesus saw into the heart of the rich young man, whom he loved, and said, "One thing you lack: sell all you have, give it to the poor . . . and come follow me!" [Mark 10:17–22] It was a matter of course for Jesus that his disciples should hold no personal possessions but rather practice a communism of the shared purse [John 12:6]. Only one man was entrusted with the hateful responsibility of managing the disciples' money, and he broke under it – a lesson with no little significance for our money-possessed society today.

Yet even Christ's betrayal and execution did not mean defeat. The enthusiastic experience of the Spirit with which the Risen One endowed his itinerant disciples gave them the power to carry on their communal life on a larger scale. The first church became an

3. Jean de Labadie (1610–1674) was a French Pietist who founded a community that practiced community of goods, joint education of children, and a simple lifestyle. —*Ed.*

Efforts to organize community artificially can only result in an ugly and lifeless caricature.

intentional community of several thousand people who, because love was burning in them, had to stay together. In all questions regarding communal life, the forms that emerged were in keeping with an understanding of life as one unified whole.

The first Christians in Jerusalem possessed nothing privately. Whoever owned property felt inwardly compelled to share it. No one had anything that did not belong entirely to the church. Yet what the church owned was there for all.

Since this generous love cannot exclude anyone, this circle of Spirit-gripped people was soon known for their open door and their open hearts. At the time of the Church's first flowering, they found ways to reach all people. They won the love and trust of their fellow men, even though in their struggle for genuine life they were bound to become the target of hatred and lethal hostility. The reason for their strong influence must have been that they were wholly heart and soul for others – for that is the only way for many people to be "of one heart and one soul" with one another [Acts 4:32].

The Spirit in Community

Private property, personal fortunes, and social privileges can only be overcome through the uniting power of the Spirit, who builds up fellowship and removes the obstacles that block

us from becoming brothers and sisters. This is a dynamic spiritual process.

The Spirit blows like the wind – he is never rigid like iron or stone. He is infinitely more sensitive and delicate than the inflexible designs of the intellect or the cold, hard framework of legalistic organizational structures – more sensitive even than the emotions of the human soul or the faculties of the human heart, the basis on which people so often try in vain to build lasting edifices. But just for this reason the Spirit is stronger and more irresistible than all these things, never to be overcome by any power, however vast.

In nature, the things that seem to last the longest – rocks and inorganic minerals – are also the most dead, while the delicate organs of living creatures are far more vulnerable to harm. Yet wherever organic life overcomes the obstacles in its way, it thrives. Similarly, wherever the Spirit fills a life strongly and purely enough to overcome rival powers, such a life can defeat death – indeed, can defeat it permanently. This was the case with Jesus. Yes, such a life can end, just as Jesus was killed in what seemed to be the end. But even in his dying, his life asserted itself as love: love without violence, love that does not claim its own rights, and love without the desire to possess. Because of this, Jesus is now all the stronger, living on powerfully as the Risen One through the Spirit as the

inner voice and the inner eye within us.

The light of the early church likewise illuminated the path of humankind in only one short flash. Yet its spirit and witness stayed alive even after its members had been scattered and many of them had been murdered. Again and again through history, similar forms of life arose as gifts of God, expressions of the same living Spirit. Witnesses were killed, and fathers died, but new children were – and are – born to the Spirit again and again.

Efforts to organize community artificially can only result in an ugly and lifeless caricature. Only when we are empty and open to the Living One – to the Spirit – can he bring about the same life among us as he did among the early Christians. The Spirit is joy in the Living One, joy in God as the only real life; he is joy in all people, because they have life from God. The Spirit drives us to all people and brings us joy in living and working for one another, for he is the spirit of creativity and love realized to the highest degree.

Community life is possible only in this all-embracing Spirit and in those things he brings with him: a deepened spirituality, an ability to experience life more keenly and intensely, a sense of being wrenched by unspeakable suspense. Surrendering to this Spirit is such a powerful experience that we can never feel equal to it. In truth, the Spirit alone is equal to himself. He quickens our energies by firing the inmost core – the soul of the community – to white heat. When this core burns and blazes to the point of sacrifice, it radiates outward to great distances.

Martyrdom by fire thus belongs to the essence of life in community. It means the daily sacrifice of all our strength and all our rights, all the claims we commonly make on life and assume to be justified. In the symbol of fire the individual logs burn away so that, united, its glowing flames send out warmth and light again and again far and wide.

Nature's Symbols of Community

Nature, with all its variety of life forms, is a parable that portrays the community of God's kingdom. Just as the air surrounds us, or as a blowing wind engulfs us, we need to be immersed in the blowing Spirit, who unites and renews everything. And just as water washes and cleanses us every day, so in the intensified symbol of baptism by immersion we witness to our purification from everything that is of death. This "burial" in water, which happens only once, signifies a complete break from the status quo; it is a vow of mortal enmity toward the evil in us and around us. Similarly, the lifting out of the water, which also happens only once, is a vivid image that proclaims resurrection. We see signs of this same resurrection, too,

in our agricultural work: after the dying of autumn and winter comes the blossoming of spring and the fruit-bearing of summer; after seedtime comes harvest.

Symbolism can be found in the most trivial parts of human existence, such as our daily need to eat. When approached with reverence, even regular shared mealtimes can become consecrated festivals of community. The ultimate intensification and perfection of this expression of community is the symbol of table fellowship in the Lord's Supper. Here the meal of wine and bread is itself a testimony that we take Christ into ourselves. It bears witness to the catastrophe of his death and to his second coming – and to his church as a body united in a common life. So too, each day of shared labor within a working community is a parable of life's sowing and reaping – of humankind's beginnings and of its final hour of decision.

The Body and Community

By the same token, the nature of each human being as an ensouled body is a parable for the indwelling of the Spirit in his creation. That is why the human body is to be kept utterly pure as a vessel ready to receive God.

Marriage is the unique intensification of this symbol of the unity of body and soul. As the unity of two people in a bond of faithfulness between one man and one woman, marriage is a picture of the unity of the one Spirit with humankind – and indeed, the unity of the one Christ with his one church. When a person enters into the sacred symbol of marriage, self-disciplined purity and a tempered sexual asceticism take new form as liberating joy in the creation of life. We are not at enmity with life – only we know that the body and its drives cannot determine what we are and do. The body is to be a living instrument of the Spirit, whether in the married state or, for some, through consecration to the coming kingdom in lifelong virginity.

In the human body, community is maintained only by constant sacrifice, as dying cells are replaced by new ones. In a similar way, the organism of a healthy church community can only flourish where there is heroic sacrifice. Such a community is a brotherhood of free-willing, dedicated self-sacrifice. It is an educational fellowship of mutual help and correction, of community of goods, and of common work that fights on behalf of the church militant. Here, justice does not consist in making and satisfying even reasonable demands for personal rights. On the contrary, it consists in giving each member the opportunity to risk everything, to surrender himself completely so that God may become incarnate in him and so that the kingdom may break into his life with power. Such justice

Joy in work is what makes community possible.

cannot take the form of hard demands made on others, however, but rather of joyous self-sacrifice. Here, the realities of God's future come into effect already now – they appear as willingness, delight in work, joy in people, and dedication to the whole. Joy and enthusiasm take shape as active love. God's Spirit comes to expression as cheerfulness and courage in sacrifice.

Work, Creativity, and the Arts

When working men and women voluntarily join hands together, renouncing everything that is self-willed, isolated, or private, the free fellowships that they form become signposts: pointers to the ultimate unity of all people in God's kingdom of love. The will that animates this peaceable kingdom, which someday will include every human being, comes from God. So does the ungrudging spirit of brotherliness in work. Work as spirit and spirit as work – that is the fundamental nature of the future order of peace, which comes to us in Christ.

Such work – that is, joy in striving for the common good side by side with fellow laborers – is what makes community possible. This joy will be ours if we, in doing even the most mundane tasks, always remain connected in a holy bond to the Eternal. Then as we work we will recognize that everything earthly and bodily is consecrated to God's future.

We love the body because it is a consecrated dwelling place of the Spirit. We love the soil because God created the earth through the call of his Spirit, and because God himself calls it out of its uncultivated natural state so that it might be cultivated by the communal work of man. We love physical work – the work of muscle and hand – and we love the craftsman's art, in which the spirit guides the hand. In the way spirit and hand work through each other we see the mystery of community.

We love the activity of mind and spirit, too: the richness of all the creative arts and the exploration of the intellectual and spiritual interrelationships in history and in humanity's destiny of peace. Whatever our work, we must recognize and do the will of God in it. God – the creative Spirit – has formed nature, and God – the redeeming Spirit – has entrusted the earth to us, his sons and daughters, as an inheritance but also as a task: our garden must become his garden.

75

We acknowledge the invisible reality and unity of the universal church.

The Organism of the Church

The body itself is a parable of the kingdom, a sign that God will win the earth for himself, filling it with peace and joy and justice. Then humankind will become one organism, just as each living body consists of millions of independent cells. This organism already exists today, as the invisible church.

When we acknowledge the church's invisible reality and unity, we acknowledge its freedom in the Spirit – and, at the same time, the need for church discipline through the Spirit. The more confidently and autonomously a group with a specific vocation follows its path, the more deeply it must remain conscious of belonging to the unity of the *una sancta* – the one universal church. And just as urgently, it needs discipline and formation through the mutual service of the universal church, arising from its ecumenical unanimity in matters of faith and life.

All individual fellowships, households, communities, or settlements are (if spiritually alive) simply autonomous cells in the one great organism. On a smaller scale, individual families and persons are autonomous cells within the group of which they form a part. The autonomy of all these individual cells consists in the specific way that each of them lives for the whole. The life of each cell builds up the community of cells to which it belongs.

Freedom in Community

How can this be? The secret lies in two things: the freedom of self-determination, and self-surrender to the whole. For individuals, this means what philosophers have called the freedom of the "good will."[4] This freedom, which is indispensable to communal life, is equally opposed to paternalism and domination on the one hand, and to a dissolute laxity on the other. In a community of people gripped by faith in the Spirit, the individual's freedom consists in his free decision to embrace the communal will brought about by the Spirit. Freedom, working within each member as the will for the good, gives rise to unity and unanimity, because the liberated will is directed toward the unity of God's kingdom and toward the good of the whole human race. Such a liberated will gains a most vital and intense energy.

Standing as it does in a world of death, the liberated will must constantly assert itself against the destructive and enslaving powers of lying, impurity, capitalism, and military force. It is engaged in battle everywhere: against the spirit of murder, against all hostility (including the venom of the taunting, quarreling tongue), against all the wrong and injustice people do to each other. That is, it fights in public as well as in private life against the very nature of hatred

4. Immanuel Kant describes the freedom of the good will in *Groundwork of the Metaphysics of Morals* (first published in 1785). —*Ed.*

and death, and against all that opposes community.

The call to freedom is a call to a battle without pause, a war without respite. Those who are called to participate must be continually alert. They need not only the greatest willpower they themselves can muster, but also the aid of every other power yielded them by God, in order to meet the plight of the oppressed proletariat, to stand with the poor, and to fight against all evil in themselves and in the world around them.

This fight against evil, against all that poisons or destroys community, must be waged more strongly within a community than against the world outside, but it must be waged even more relentlessly within each individual. In a communal life, all softness, all flabby indulgence, is overcome by the burning sharpness of love. The Spirit of community takes a combat position within each individual, fighting against the old man from the standpoint of the new and better man within him, of man as he is called to be.

Vocations and the One Church

It is clear that the war of liberation for unity and for the fullness of love is being fought on many fronts with many different weapons. So too, the work of community finds expression in many different ways.

Some might be tempted to believe that a life without personal property in community of goods is the only way to be a follower of Jesus and a member of his church on earth. But this would be an error. We must recognize the astounding diversity of tasks and vocations that belong to the church militant. Still, for each one of us there is a certainty of purpose for every stretch of the way we are called to go. Only where there is direct certainty about one's vocation can there be loyalty and an unerring clarity (even in little things) to the very end. Only those who hold firm can bear the standard; but to those unable to endure, nothing can be entrusted.

Accordingly, humans do not receive some high commission from God without also receiving a specific, defined task. Obviously, a greater, more comprehensive vocation can absorb a former, more limited one (this is the only way one vocation can supplant another). But it is no diminution of God when apostles, prophets, martyrs, teachers, elders, and deacons acknowledge both God and, with him, the particular task, service, or commission to which he has called them. What is decisive is that any specific vocation leads only to *Christ:* that it serves the whole of the church and advances the coming kingdom.

Wherever people see their particular task as something special in itself, they

77

will go astray. But anyone who serves the whole in his own specific place and in his own characteristic way can rightfully say: "I belong to God and to life in community," or to God and any other calling. Before our human service can become divine service, however, we must recognize how small and limited it is in the face of the whole. Then a special calling – living in community, for instance – must never be confused with the church of Christ itself.

Life in community means discipline in community, education in community, and continual training for the discipleship of Christ. Yet the mystery of the church is something different from this – something greater. It is God's life, and coming from him it penetrates the discipline of community. This penetration of the divine into the human occurs whenever the tension of desperate yearning produces an openness and readiness in which God alone may act and speak. At such moments a community can be commissioned by the invisible church and given certainty for a specific mission: to speak and act – albeit without mistaking itself for the church – in the name of the church.

That is why, in the life of a community, people will be confronted by several decisive questions again and again: How am I called? To what am I called? Will I follow the call? Only a few are called to the special way that is ours. Yet those who are called – a small, battle-tried band, who must sacrifice themselves again and again – will hold firmly for the rest of their lives to the common task shown them by God. They will be ready to sacrifice life itself for the sake of the common life.

People tear themselves away from home, parents, and career for the sake of marriage; for the sake of wife and child they risk their lives. In the same way it is necessary to break away and sacrifice everything for the sake of our calling to this way. Our public witness to voluntary community of goods and work, to a life of peace and love, will have meaning only when we throw our entire life and livelihood into it.

Daring the Venture

It is now [1925] over five years since our tiny fellowship in Berlin decided to venture, in the sense of this confession, to live and work together in community on a basis of trust. And thus our small intentional community was born. We were a handful of people of the most varied backgrounds and professions who wanted to place themselves wholly in service to the whole. Despite disappointments and difficulties, despite changes in membership, we are now

5. Kees Boeke (1884–1966) was a Dutch reformist educator and (at the time of writing) a Christian anarchist and pacifist. His 1957 book *Cosmic View* would go on to inspire the 1968 films *Cosmic Zoom* and *Powers of Ten.* —*Ed.*

around twenty-five to thirty adults and children.

Whatever any of the permanent members acquires in the way of income, property, or possessions, we turn over unconditionally to the common household. Yet even the community household as a closed group does not regard itself as the corporate owner of its inventory and enterprises. Rather – like the community around our friend Kees Boeke[5] in Bilthoven, Holland – it acts as a trustee of the assets it holds for the common good of all, and for this reason it keeps its door open to all. By the same token it requires for its decision-making full unanimity in the Spirit.

Based on the various gifts and professions of our individual members, several areas of work have developed belonging to the community: (1) publishing of books and periodicals; (2) school and children's home; (3) agriculture and vegetable gardening; (4) youth work and hospitality.[6]

Given our basis of faith, we cannot approach the development of our community from a purely economic point of view. We cannot simply select the most capable people for our various work departments. We aim for efficiency in all areas; but far

more important, we seek faith. Each person – whether committed member, helper, or guest – must be faced again and again with the question whether or not he is growing into the coming community ruled by Christ, and in what special vocation he is called to serve Christ's church.

Our work, then, is a venture dared again and again. Yet we are not the driving force in this – it is we who have been driven and who must be urged on. The danger of exhaustion and uselessness is always present, but it is continually overcome by the faith that underlies mutual help. ⤳

<hr>

This essay was originally published in Die Wegwarte *in October 1925 and again in May 1927. The new complete translation here is by Peter Mommsen. It partially incorporates an abridged 1995 translation by Christopher Zimmerman, which appears together with two responses by Thomas Merton in the book* Why We Live in Community *(Plough, 1995).*

Our witness to community will have meaning only when we throw our entire life and livelihood into it.

6. The original includes details about Arnold's community's enterprises, which are omitted here.—*Ed.*

Amity and Prosperity: One Family and the Fracturing of America
Eliza Griswold
(Farrar, Straus and Giroux)

America is fracturing politically, but Griswold has a more literal fracturing in her sights as well: the fracking of shale beneath the small Appalachian towns of Amity and Prosperity in southwestern Pennsylvania. Just as coal did in another era, the gas boom promised a lucky break for residents no longer able to make a living on the land. Some profited, but at what cost? The book opens with poisoned pets and ailing children, and pits an indefatigable single mom and two local lawyers against energy giants and neighbors' recalcitrance. Built on seven years of immersive reporting, this is human interest journalism at its best.

Squeezed: Why Our Families Can't Afford America
Alissa Quart (Ecco)

A report on the plight of the American middle class could easily come off as self-interested (what about the desperately poor?) and predictable (the 2008 financial crisis put to rest the myth that college guarantees security). A disciplined journalist, Quart avoids that fate, framing her facts and figures with unsettling personal stories of financial ruin triggered by getting sick or pregnant, professors on food stamps, twenty-four-hour child care, breadwinners displaced by computers, and so on. She recognizes that her subjects' plight is not their fault. But her solutions – DIY survival strategies and European-style social democracy – seem hopelessly inadequate. What stays with you is the precariousness and stress to which today's capitalism subjects millions of even relatively privileged people. Can a system so anti-family really be the way we are meant to live together?

Dinner at the Center of the Earth
Nathan Englander (Knopf)

A hapless spy, troubled by the lethal consequences of his profession, decides that leaking information to the enemy will somehow break the cycle of violence. Instead, he finds himself disappeared to an undisclosed location in the Negev with an even more hapless lone guard.

Even the best writers can't be expected to make sense of the intractable conflict between the Palestinians and Israelis. But Englander, a master of the craft, has certainly captured its senselessness; perhaps the only thing more absurd than the layered spy story he conjures is the reality that inspired it. An American Jew, Englander moved to Israel in 1996 because peace was about to happen and he didn't want to miss it. Instead he got the second intifada. That heartbreak has, belatedly, given us this remarkable novel.

The Aviator
Eugene Vodolazkin (Oneworld)

From the author of *Laurus,* translated from the Russian, this is Rip van Winkle for the age of cryonics. A young man wakes up in a hospital and, gradually, random memories emerge and coalesce – eighty-year-old memories. Who was he? And what happened to him? Will he ever truly belong to the world in which he finds himself? Fame is a given, but can he find love? Can his unreliable recollections recreate a slice of life that history failed to record? Narrated entirely as journal entries, this unconventional novel is a playful mockery of historic and scientific hubris that is at the same time an earnest critique of both the Soviet terror and contemporary life. ⤙ *The Editors*

The Sacred Bonds of
Sound

SARAH RUDEN

We are no longer used to letting sound touch us. Perhaps this is because we are no longer used to silence. As a Quaker, >>

>> belonging to a community that worships in silence, I've experienced how it is the surrounding stillness that gives the spoken word its power.

Above, a visualization or "sound-form" of the sound waves made by a US soldier overseas singing for his wife. By Ashik and Jenelle Mohan.

Sound cradled in silence has been essential to me in understanding scripture more deeply. The translation of ancient literature is my livelihood, and Bible translation reform is my passion. Why is it that to so many today, the Bible comes across as dull? Much of the blame seems to rest with English translations, which still carry the momentous seriousness of Reformation piety and a vast accumulation of elite scholarship, and so do not communicate anything of the original Hebrew and Greek texts' earthy delights. But these delights themselves sprung from the fertile ground of ordinarily quiet lives, like those of small children; this, I think, is what made the sounds so vivid and precious.

To give my lecture audiences a sense of what listening to the text was like when it was fresh – and most of scripture's first audiences did only listen; physical books were precious, and shared through reading aloud – I sing a little of a Sunday school song. This is the sort of composition people embrace, and remember – impulses essential to sacred literature's place in our hearts and communities:

The Lord said to Noah, "There's gonna be a
 floody, floody."
The Lord said to Noah, "There's gonna be a
 floody, floody.
Get those animals out of the muddy, muddy,
Children of the Lord!"

The adult listeners tend to chuckle and stir in their seats. I always have a hard time establishing that they are hearing not just an appealing vestige of childish goofiness (which is perhaps even disrespectful to the story in which it is situated) but the essence of the Judeo-Christian tradition as expressed in literature: the joyful words, the beloved words, the shared words, the words that are unforgettable because of their overt patterning. In making my argument, I like to quote the most accurate translation that scholars have been able to come up with, in the face of the silly pun, for Genesis 2:25–3:1: "Now the man and his wife were nude . . . but the snake, *he* was shrewd. . . ." This isn't a bizarre exception, I insist; and I make an effort, once I have people's attention, to adduce more solemn but equally striking examples of the Bible's patterned words.

Sarah Ruden is a poet, translator, essayist, and popularizer of biblical linguistics. Her translations include Augustine's Confessions, The Golden Ass, *and* The Aeneid. *She is also a published poet and the author of several books, including* Paul Among the People: The Apostle Reinterpreted and Reimagined in His Own Time *and* The Face of Water: A Translator on Beauty and Meaning in the Bible.

The folk-dance and campfire qualities of the Hebrew Bible extend into the Greek New Testament, with its poetic stunts, apparent fragments of popular hymns, and tongue-in-cheek interpretive quotations from the Septuagint, the Greek translation of the Hebrew Bible that served as the contemporary Jewish Diaspora's scripture.

Are these memorable sounds something to put away with childish things, to be left behind in the church basement or Scout hall? The ancients certainly wouldn't have thought so. They listened to literature the way we look at an Old Master painting or a pixelated puzzle-image: with lively and prolonged engagement.

Classicists and biblical scholars have known about the importance of sound for a long time. The vagueness of color words in the Greek Homeric epic poems – sonic masterpieces in themselves – must reflect this hierarchy of perception. *Glaukos* covers green, blue, gray, and maybe lavender, *xanthos* brown, tan, yellow, and maybe orange. Besides black and white, only the word for red, *eruthros,* the color of a warrior's streaming blood, is an unambiguous descriptor. Compare the visual discernment expected today in someone choosing wall paint or a prom dress, identifying a butterfly, or just describing a sunset: "teal," "chartreuse," "millennial pink," "eggshell," "burnt umber," "burgundy," "saffron."

Biblical Hebrew is even less interested in what colors things are, and in general less interested in any visual details – which makes sense. While the visual arts flourished on all sides of the Holy Land, Jewish culture held representative images and even finery suspect: they were suggestive of idolatry, frivolity, and disruptive inequality. Joseph's "coat of many colors" (Gen. 37:3), the description in standard translations, gets him into a lot of trouble – but the Hebrew actually says nothing about color:

it is literally a "coat of the flats of hands or feet," probably either with sleeves or a train luxuriously impeding heavy labor, or a block or striped pattern woven or stamped in. It doesn't take a couture rainbow (which would have necessitated a variety of dyes that weren't available) but just *some* elaboration of the ordinary type of garment to violently upset a family's equilibrium.

But patterned sound – the kind we tend to look down on as "empty rhetoric" or "jingles" or "rhyme and chime" – was a cultural feast that evoked no envy or suspicion, probably because it was so broadly shared. In the synagogues that spread through the Holy Land and beyond from at least the third century BC, men and women, the young and the old, and Jews and gentiles could all partake of these beautifully arranged words.

An example that's rudimentary and authoritative and supremely clever all at the same time is the deployment of alphabetic acrostics in Psalms and Proverbs. In the original texts of these passages, each line or verse is marked not with a number (numbered divisions of the Bible are modern), but with a Hebrew letter in its proper sequence, beginning the first word.

I like to think that this was not only a celebration of the writing system, the means of making God's word visible, treasuring it up, and spreading it to remote places; in addition, given the prevalence of primary-school memorization feats in surrounding cultures, it would not be surprising if Jewish pupils learned the alphabet through an entire Psalm or a passage of Proverbs. The apparent melody names attached to some Psalms, and the musical instruments mentioned in the text, may not pertain only to

> The ancients listened to literature the way we look at an Old Master painting.

adult performances; it is not impossible that learning the aleph-bet-gimel during the first few days at a synagogue school was more like choir practice than like the brief collection of syllables we cause English-speaking children to recite, which is set to baby music and jams the middle span of letters into a single hasty word, "elemenopea." The teaching of arithmetic in the synagogues may also have been enticingly elaborate. Jewish folklore through the ages displays poetic and musical lists and enumerations, some of which are enshrined in celebrations like that of the Passover.

This prompts me to suggest a social meaning to the vital term *Logos,* usually translated as "Word," in the Book of John. The term is connected to mathematics, whose power and prestige thinkers since before Plato had been emphasizing: some things are demonstrably and eternally true, in all languages and to all people at all times and places; the Logos in John is the reasoning of God and eternity; it creates and transcends the physical universe. But the Logos can also be "the compelling story"; it can be the Gospel accounts of Jesus' life, teachings, death, and resurrection, accounts spread around the world

Christians are a family that live, move, and have their being within a great story.

through word of mouth in the lingua franca of the Koine Greek dialect, and on cheap papyrus paper. Like a times table, the story is simple, essential information, accessible to anyone who "has ears."

But the story will not spread on its own, and here is where verbal form and performance come in. Like the times table, you would not want to present the story to the uninitiated as a set of bald facts; you organize it, make it memorable, and have the children recite it together, as a sort of ritual. The benefit is not only that it is easier to remember, but also that it attaches itself to your heart and through this attaches you to other people.

A concern for community-building verbal performance is evident in Paul's letters – and his challenges were great in this regard, as the proto-Christian assemblies were starting from no fixed tradition. They did not duplicate synagogue practices; they allowed women to speak at this early stage, though women's educational deficit was enormous – what did they have to say, and how well could they say it? Nonetheless, the substance of the early gathering appears to have been free and spontaneous "speaking out," the literal meaning of the Greek word normally translated as "prophesying."

What tends to pass today for Paul's controlling attitude toward the assemblies seems to me, in historical context, to have been more like his efforts to bring minimal order, so that the harmony of shared words could take hold and help generate the shared love, joy, praise, and gratitude on which the apostle knew this new faith depended. And the assemblies did have very limited resources: only the rudiments of the Gospels existed at this period, probably just a few distinctly Christian prayers and hymns, and letters like those of Paul himself. The impression from those letters is that worship was built mainly on individual speech. As for the community's activities as a whole, out of the nine spiritual gifts enumerated at the end of 1 Corinthians 12, six consist of whatever a member of an assembly chose to say. Paul set about shaping Christian expressive language not, it is clear, to exert control over thought but to keep Christian culture from

being shapeless, in which case it would have had no cohesion or staying power.

The neglected 1 Corinthians 14, for example, is a plea to tamp down unintelligible speaking in tongues, or at least to make sure that there is an attempt to interpret the utterances; silence is better than contributions that do not "build up" and "encourage" all those present. "Speaking out" or "prophesying" and listening must be done in courteous turn and not willy-nilly.

The vast edifice of Christian scripture and other literature, liturgy, and music rests on such strictures. An all-powerful God could not conceivably *need* such performances, but communities of believers need them very much. Christians are a family that live, move, and have their being within a great story, but it isn't a story they inhabit passively or imbibe academically, it's a story they enact constantly for each other. What comes out of their mouths, therefore, must be as orderly, as exemplary, as the way they live.

This history and these principles fascinate me as a Quaker, because Quaker Meeting for Worship is a self-conscious imitation of primordial Christianity. According to a verse cherished by founders of the sect, John 15:15, Jesus calls his followers not servants but friends, to whom he gives directly the entire revelation he has received from God. Hence among Quakers there is no worship leader, only a person who "sits head" of the Meeting, to ensure "right ordering": to start and end the silence on time, to intervene in any case of urgent need, and to discourage any impropriety, such as argumentative answering back or the failure to "frame each contribution in silence." Anyone, including a child or a new, uninvited visitor, is welcome to speak out of the silence, but only briefly and to the point, and only on a topic and in a manner helpful to the group. This is definitely not a time for self-centered self-expression. The "openness to new Light" that a Meeting seeks demands the putting aside of whatever may stand in the Light's way, especially the competitive individualism modern culture embraces.

Quaker Meeting is thus an outwardly simple proposition, in which any reading out loud, any story even inwardly rehearsed, any set prayer or other memorized recitation, or any musical performance except of the most spontaneous kind is frowned on. This is how Quakers invite the Holy Spirit to reveal God's will to the entire group. And in fact a mysteriously "gathered Meeting" has a silence so deep that you can practically hear in it an airy, rushing motion, like wings; you are not at all surprised by the expressions of excitement and thankfulness afterwards.

A sound-form depicting Hungarian fiddle music. By Ashik and Jenelle Mohan.

But it is also telling that technically forbidden aesthetics intrude all the time. It is no strain to keep objects out of Meeting, though some Meetings allow a simple one like a candle or a vase of flowers (but not a symbol freighted with its prior meaning, like a cross) to be placed in the middle for contemplation. But just try to suppress rhythms and other elaborations of speaking, especially humor and fantasy; their suppression doesn't seem to be something the human brain is designed to do.

The convener of a Quaker building committee may intone during Meeting for Worship, "God maketh the rain to fall on the just and the unjust, but no longer in this room." He has obviously planned this statement. A Quaker with a recognized "gift for vocal ministry" speaks during the first ten minutes of Meeting every Sunday, as to how some experience during the week was revelatory for her and might be for others. Since her stories, though clearly not spontaneous, are intelligent and enjoyable, she is never "eldered" in private for "inappropriate ministry."

Music pushes in from all sides, and now that Quakers no longer have the strict rules for "plainness" that used to keep even their quilts pure white and their clothing black or gray, there is no sense in pushing back too hard. Some locales feature a Meeting for Singing before Meeting for Worship, so that people can get it out of their system – or try to. Among those acculturated to cooperate and

defer – Quaker tradition mandates complete, careful consensus for all decision-making: we never vote and produce winners and losers of deliberations – it's comical to see pent-up musical tastes gently and slyly jostling for expression. Well, it would be comical to an outsider: I know from my own innards the feeling that we *have* to, *we have to* sing a particular hymn I know from my Methodist upbringing. Most Friends these days are, like me, "convinced" or converted as adults: we wake up with the religious music of our childhoods in our heads, we hum it while doing housework, and nothing can replace it. Similarly, I think, in the great sweep of history Christians long for the music of our faith's origins, the patterned sounds that spread the Word over the world.

t's therefore worthwhile to pay some attention to the beauty we have lost and how we might get some of it back. First of all, silence, the state of the trustingly listening and learning small child, seems important. The Gospel command to "become as children" can have theological meanings, but Quaker experience points up a practical one: habitual silence endows meaningful sound, when it occurs, with emotional intensity. This was the condition throughout the ancient world, in which aesthetic experience was special and not ubiquitous. Plato prescribed that the state

take over all poetry and music so as to better control citizens for the state's ends – particularly warfare. The synagogue and the Christian assembly made more grounded and more democratic uses of the aural arts, with predictably much better results than those of Plato's totalitarian adventures in Sicily. In any case, an essential condition of groups' doing anything useful with these arts was the absence of music that was either ambient in public or selected by individuals for their sole enjoyment.

Today, it no longer takes a blue-nosed objector to rock 'n' roll to deplore the modern dead ear. It in fact seems to make little difference what music comes through ear buds hour after hour. The natural inability to take much account of it in competition with commuting, work, eating, socializing, exercising, and consuming other media by sight causes a deep dip in taste and sensitivity, which allows composition standards to decline, which allows further dips in taste and sensitivity.

While I lived at a divinity school as a visiting scholar, two kinds of relationships of the younger students to music struck me. First, there was the iTunes attachment to "my" music; but propagandizing a favorite band appeared seldom to work, as most of the new songs pouring into the marketplace were hard for me even to distinguish from each other. Without rudely asking, "What on earth do you like about this music?" I could gather that the answer would be something like "I found it, and not many other people know about it," or "It's something different," or "I go to the concerts" – but never "It's good because . . ."

I perceived a pervasive trouble in relating even a relatively shallow manifestation of the self – here, the musical taste of someone who isn't a musician – to roles in society. A young child, reveling in her parents' love and combatting the inherent anxiety about survival and fulfillment, will normally think, "I'm more beautiful than anybody!" – but in time will be content that her body is merely useful in pursuing what is transcendently beautiful to many people, such as a faithful marriage or a warm family life. But American culture is now so distorted that the mere preference for a shrill or dull tune and silly lyrics is enfolded into a stubborn notion of isolated, individual specialness, where it has no function but to be confirmed and defended.

But another kind of relationship of the students to music cheered me a great deal. Many of my neighbors at the divinity school attended musical parties, ecumenical gatherings at which people searched with furtive urgency through hymn books but nervously deferred to others' choices, all the time gritting their teeth at the thought of going home without having shared a favorite. Sharing the performance was the point; nothing would prevent them humming or singing the song when alone, and YouTube has nearly everything on it, for free. Instead, they wanted to *sing* the good stuff – and there actually weren't great differences in their ideas of what was good – together, in person.

No amount of iTunes could kill the urge of the divinity students to make joyful noises together. For relief from the deadening clamor of today's commercial culture, we can experience the bonds of sound in a way the Psalmist would understand: as a community making music with one another. But it is more than just a relief; it might be one of the closest things to God's kingdom that we can have here on earth. ⟩⟨

No amount of iTunes can kill the urge to make joyful noises together.

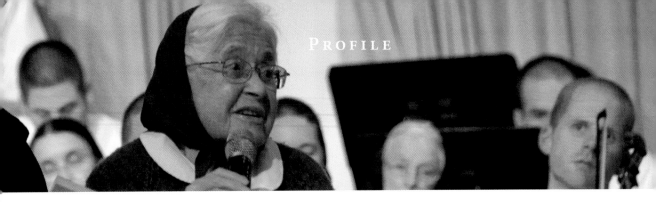

Making Music for Community

An American composer's journey to the Bruderhof

MAUREEN SWINGER

"**YOU WON'T BELIEVE IT!**" ran the letter, "We have a new visitor at Woodcrest, and she's setting your husband's poems to music!" The year was 1959, the writer, Lois Ann Domer, an enthusiastic young American at the Bruderhof's then five-year-old community in New York. The recipient was Emmy Arnold, who with her husband Eberhard, had started the Bruderhof in 1920 in Germany.

Marlys Swinger introducing one of her choral works, 2014

After Eberhard's death in 1935, Emmy had saved copies of her husband's exuberant poetry. The early poems were declarations of lifelong faithfulness from her young suitor, whose love for her was only surpassed by his love for Jesus. Later poems told, too, of the joys and disappointments of the communal life they had begun. Several had been set to music over the years, but perhaps none with the sensitivity now expressed by a young minister's wife from the Midwest.

Marlys Blough was born on an Illinois farm in 1926. She grew up gardening, canning, driving a tractor, and playing music: she begged for piano lessons at age six, and picked up violin at twelve. In high school she added snare drum in order to join the band. Later she enrolled at Chicago's American Conservatory of Music, to study "piano, theory, analysis, counterpoint, harmony – all the great things you can do with music."

Meanwhile, her future husband, Glenn Swinger, attended Bethany Theological Seminary. They crossed paths at the local Church of the Brethren youth group. He was the tallest man in the room; when not studying the Bible he played basketball. He also possessed "the most beautiful natural tenor voice I ever heard," she still declares. He, too, had been raised on a farm during the Great Depression. In the evenings he would follow the sound of gospel spirituals from the black church across the road. His mother's disapproval didn't stop him from slipping in the back door to soak up the sound of God's glory. No one ever kicked him out.

Through high school, college, and seminary, Glenn sang in glee clubs and choral groups. But now there was Marlys, and the hope of a future grounded in shared faith and love of music. They were engaged on Valentine's Day, 1947, and married at the end of that summer.

Maureen Swinger is an editor at Plough *and lives in Walden, New York, with her husband, Jason, and their three children.*

A five-year pastorate in the Ozarks followed; then another for three years at the Roanoke Church of the Brethren in Louisiana. By now, they were parents of two girls and two boys.

But, Marlys remembers, "Glenn always felt a tug to a more radical way, a way to live out the Sermon on the Mount. In our third year in the Roanoke Church he said he couldn't take it anymore, because he felt we were not really serving Jesus." Big questions about poverty, inequality, and unjust war were crying out to be addressed, but bringing them up in church tended to create a loud silence. A coterie of their friends was increasingly dissatisfied and, by ones or twos, they were traveling cross-country to Woodcrest, the first Bruderhof community in North America.

In the 1950s, Woodcrest welcomed waves of people from all across America, all looking for a way to live out the Sermon on the Mount. Glenn and Marlys were astounded by the simple but joyous life they found. They and their children were drawn immediately into the whirl of communal life.

In the midst of all this, Marlys's musical talent became a calling. Here was a two-hundred-voice community choir raring to learn some of the big oratorios. An orchestra emerged from the motley ranks, but who could guide such a range of singers and players through Mendelsohn's *Elijah*? From the piano in the middle of the room, Marlys thumped out the vocal parts and covered instrumental gaps.

But it wasn't long before she composed her own music. As the community anticipated the baptism of some of the Swingers' close friends, Marlys recalls, "I was very moved and wanted to take part somehow." She took part by writing a powerful interpretation of Psalm 130: "Out of the depths, we cry to Thee."

Her setting opens with the strings and chorus dragging and earthbound, mourning for all of burdened humanity: "If Thou shouldst mark iniquity, who then shall stand?" Then voice and violin harmonize in the psalm's echo of "Comfort ye my people," offering a hope that had seemed beyond reach: "But there is forgiveness with Thee." And like a prayer flinging upward comes the joyous assurance, "Our hearts wait for the Lord, more than the watchman waits for the morning."

The Swingers made their formal commitment as members of the Bruderhof in August, 1968. Their decision estranged them from family for years (a rift that did heal) but by then they knew with certainty that this was the life for them.

AMONG THE MANY families the Swingers soon got to know at Woodcrest were the Clements: Jane, a poet, and Bob, a lawyer. The first Jane Tyson Clement and Marlys Swinger collaboration was ad-hoc. Jane dropped in one evening with three verses jotted down on notepaper.

> Small blue swallows skim the grass,
> the south wind breathes upon the hill,
> The pine stands tall and dark and still,
> Come, my beloved . . .

A young couple was getting married in a few weeks. Would Marlys consider turning the poem into a song for them? She would – and from that moment, no wedding could slip by without an original Clement-and-Swinger song. Each new baby occasioned a lullaby. The high school choir got rollicking autumn tunes, and the elementary grades had their own Easter cantata, with songs reflecting Jane's naturalist bent: crocuses pushing through frozen earth, moths breaking free of cocoons, and birds returning north.

ONE CHRISTMAS the Swingers were given a chapbook by Georg Johannes Gick. Written in Germany in 1935, *The Shepherd's Pipe* is a cycle of poems giving voice to surroundings of the nativity: the shabby stable, the path leading to it, the linden tree overhanging the window, the stars shining through the roof, the candle illuminating the

Child to all who come to kneel beside him. By the next Christmas Marlys had threaded the poems into a cantata for the children's choir. With its lovely two-part harmonies, *The Shepherd's Pipe* shone in the darkened gathering hall like the candle by the manger.

Marlys also composed music for poems by Philip Britts, a young farmer whose spare, powerful poetry has just been published in *Water at the Roots* (Plough, 2018). She completed several cantatas – 1 Corinthians 13, Isaiah's messianic prophecies, the Nativity story – as well as settings of early Christian hymns. But perhaps most meaningful for the Bruderhof in the 1960s, finding its collective feet again after years of turbulence, were the rediscovered words of Eberhard Arnold. To the dozens of new American members this was a conduit to the beginnings of the radical life they had chosen. Here were songs of a fiery faith that had burned unwaveringly through hardship, songs of renewal and repentance, of the unity granted to believers of "one heart and mind."

What chance or grace brought these poets and musicians to a community where singing plays such a vital role? Since its beginning, hundreds of songs of nature, seasons, laughter,

love, and faith have been woven into the fabric of Bruderhof life. The activist Jesuit Daniel Berrigan recounted in a letter: "Dear Lord!! They sing at the slightest provocation. And sing like angels."

While any child in the Bruderhof today sings songs by Marlys Swinger, I didn't know her personally before her grandson Jason asked me to marry him. I moved to the community where she lived a few months before the wedding. Her delight in our upcoming marriage made her glow like a bride. My most treasured memory of those days is an evening spent with Grandma, singing many Eberhard Arnold songs and listening as she recalled the days when she first encountered his poems and heard the harmonies in her mind.

When we brought little Marlys – our first daughter – home, we found a lilting, whimsical little lullaby, dashed off in a day, waiting in the crib to welcome her. That baby is now ten, and her great-grandma is still going strong, looking forward to her ninety-second birthday. The piano in her living room cannot be accused of gathering dust. This year she is composing an oratorio based on the Gospel of John.

Marlys would rather write new music than talk about what she's written in the past. To her there is life to be sung, and if there isn't a song to express it, well, then there ought to be.

I try to imagine other trajectories her life might have taken. A direct launch out of the Conservatory onto the concert stage? New Brethren hymns? Children's choir in the Ozark Mountains? Good things all, especially if dedicated to God, as they surely would have been. But try as I might, I just can't hear it. She was meant to come to this place of many voices. ⟶

▶ *To hear some of the music mentioned in this article, visit* plough.com/marlys.

A Man of Honor

What same-sex-attracted Christians can give the church

EMILY HALLOCK

WHEN I WAS thirteen years old, my dad died from AIDS as a result of a same-sex relationship outside of his marriage. So when as a follower of Jesus, I get called a bigot because I believe in Christianity's teachings on sexuality, it hurts me deeply. I loved my dad; most of my happiest childhood memories were shared with him. We danced to Carly Simon. We baked Black Forest cherry cake. We sat together in our rocking chairs on warm North Carolina nights, marveling at God's universe.

But most of all I loved him because, more than any other person in my life, he pointed me to Jesus. When I was nine, he gave me the Bible I still use today. He wanted me to know how important it was to follow Jesus, come what may. He suffered intensely from AIDS, but he told me that he suffered more from his betrayal of Christ. He knew he had sinned, and was deeply sorry. I witnessed his repentance and his childlike joy when he knew he was forgiven. It remains the single most important example for my own life.

When I found out about my dad's same-sex attraction, I was shocked, not because of any scrupulous moral principles I had, but because of how he had struggled alone for so many years. He came from a Southern Baptist military family, and he'd had a difficult relationship with his own father, who had been a Green Beret. He wasn't macho or on the football team

Above, Emily with her dad, 1980

Emily Hallock is a blogger and mother of three who lives at Beech Grove, a Bruderhof in Kent, England.

Christians. All of us, he says, are subject to temptations, and all of us need help to overcome them. All Christians need the support of a church family to follow Jesus, but because many churches either refuse to discuss same-sex attraction for fear of being labeled homophobic, or encourage same-sex-attracted people to live a gay lifestyle in the same spirit of compromise, most same-sex-attracted Christians don't get the support they need.

Rather than helping him, Shaw says, churches make his life difficult by being unclear, even hypocritical, about a sin like divorce and remarriage, and by not clarifying the sacrifices required for true discipleship. He writes of what he calls "kitchen floor moments," when he feels acutely the sacrifices of the stand he is taking.

like his older brother; he was just different.

In those years, same-sex attraction was taboo, and my dad could not share his feelings at home or at church. At the same time, he felt called by Jesus and wanted to dedicate his life to him as a pastor. But what pastor was allowed to be same-sex-attracted in the 1970s? So he did the "right thing," got married, had two children, and became a pastor.

But he couldn't shake his same-sex attraction. He knew God's commands; he knew there would be no blessing on a parallel gay lifestyle, but he was unable to share his burden or ask for help. Eventually, all alone, he gave in to temptation.

THE CHURCHES failed my dad then, and they are failing people like him now, but it doesn't have to be that way. I've found Ed Shaw's book *The Plausibility Problem* a great help in this regard. Shaw, a celibate, same-sex-attracted pastor, challenges churches on their lack of support for same-sex-attracted

What will help me get up off the kitchen floor is seeing other Christians sacrifice short-term happiness out of obedience to God's Word. I'm most encouraged to obey what God says about sex by the costly obedience I see other Christians make. A good friend has been willing to sacrifice his professional reputation to take a stand for truth. Another friend persevered in a marriage nearly everyone else would have walked away from – because he knows God hates divorce. All of them are the sort of people who have most made me feel the possibility of the life that I'm living, and I praise God for them.

Such shared sacrifices are crucial to reinforcing the idea that the church is a place of welcome to same-sex-attracted disciples.

The church loses its voice and authority when it holds same-sex-attracted people to a higher standard than others; fidelity to

the gospel includes us all. We cannot ignore adultery or limply justify divorce and remarriage and cohabitation while condemning homosexuality; the Bible contains strong moral judgments on all of them. No one of us chooses our demons; they choose us, and in that sense, the church has to accept those individuals who seem to have fixed, unremitting same-sex attraction, and help them with hope and truth.

My dad died still looking for a supportive church family – a church that did not condemn, a church focused on trying to live out the Sermon on the Mount with love and care all seven days of the week. Thankfully, Shaw found a church family to fill the lonely hours when he, like other singles, found himself missing a spouse and children of his own to come home to. And I found a church family, too, when I joined the Bruderhof. Here, with my husband, Dan, and our three children, we can help each other put God's will before our own will; our faithfulness to Jesus before our pursuit of happiness. Within my own church community, I've seen gay congregants find peace and answers in either singleness or God-ordained marriage within the fellowship. If my dad had found such support, things could have turned out very differently.

It's not just Ed Shaw and my dad; there are others who've made this sacrifice, too. Sam Allberry (*Is God Anti-Gay?*) and Wesley Hill (*Washed and Waiting*) are exclusively same-sex-attracted Christians for whom celibacy is the only option to stay faithful to God's commands. Rosaria Butterfield (*The Secret Thoughts of An Unlikely Convert*), on the other hand, was able to renounce her lesbian lifestyle to marry and adopt children in the church. All

All Christians need the support of a church family to follow Jesus.

of them, out of love to Jesus, put God first and had the courage to publish their stories.

PEOPLE WITH same-sex attraction who want to follow Jesus may be among the most important witnesses of our time. They are taking a brave, uncompromising stand for the gospel that requires great personal sacrifice. They are asking the church to stand together with them. The church needs to be there for people like my dad, and for each one of us. We are all sinners, whether we are heterosexual or same-sex attracted. We cannot single out specific sins or certain individuals for condemnation, because the truth for everyone is that when we put Jesus before our self-interests, all can be redeemed.

The apostle Paul speaks of this crucial unity, praying for the day when "we may no longer be children, tossed to and fro by the waves and carried about by every wind of doctrine, by human cunning, by craftiness in deceitful schemes. Rather, speaking the truth in love, we are to grow up in every way into him who is the head, into Christ, from whom the whole body, joined and held together by every joint with which it is equipped, when each part is working properly, makes the body grow so that it builds itself up in love" (Eph. 4:14–16). If one group of believers turns judgmentally on another group, the ship of the church will founder in the storm. But when sinners – no matter what their sin – unite in their need of grace and repentance, the church will only be strengthened. ⇾

This article first appeared on bruderhof.com.

Wassily Kandinsky

JASON LANDSEL

In 1896, when he was thirty years old, Wassily Kandinsky gave up a promising career as a law professor to begin painting. A native of Moscow, he moved to Munich and immersed himself in the city's avant garde art scene. When war broke out in 1914, he returned to Moscow, but following the Revolution of 1917, he found that his Russian Orthodox spirituality was alien to the materialist ideology official Soviet art was required to embody. When, in 1921, Kandinsky was invited to teach at the Bauhaus arts school in Weimar, Germany, he left Russia for the last time.

The Nazis closed the Bauhaus in 1933, labeling its artists "decadent," and Kandinsky fled to France. He died in Paris on December 13, 1944, having painted until the end.

> **"The artist must train not only his eye but also his soul."**
>
> Wassily Kandinsky

Over the course of his career, his style developed radically: beginning in expressionism, he eventually painted one of the first purely abstract works in the European artistic tradition. True art, he believed, was not simply an accurate reproduction of external form – a house that looked like a house – but was something closer to a chord struck in the soul of the viewer.

Indeed, the link between music and art was crucial to Kandinsky's work. Overpowered by Wagner's *Lohengrin,* Kandinsky strove to call forth the same kind of experience in his viewers that Wagner's music had given him.

This experience must be the result of the artist communicating the "inner necessity" of both his own soul and the historical moment to the viewer. Artists, for Kandinsky, were prophets: they pointed the way toward a future of transformation, even of apocalypse.

Kandinsky was raised in the Russian Orthodox Church, and his faith was an integral part of his work. In his insistence that visual art must be a doorway to spiritual experience, one can see the influence of Orthodox theology of the icon. And in his rejection of materialism, one can hear the joy of an affirmation of Christian faith. In his 1910 essay "On the Spiritual in Art" he wrote:

> Our minds, which are even now only just awakening after years of materialism, are infected with the despair of unbelief, of lack of purpose and ideal. The nightmare of materialism, which has turned the life of the universe into an evil, useless game, is not yet past; it holds the awakening soul still in its grip. Only a feeble light glimmers like a tiny star in a vast gulf of darkness.

To nourish that feeble light, to give hope to people who had succumbed to the nineteenth century materialist mirage, was the prophetic role of the artist to which Kandinsky felt called.

The betrayal of this prophetic calling could be seen in the inauthentic, purely external art that Kandinsky saw in the exhibitions around him. "A Crucifixion," he lamented, "by a painter who does not believe in Christ." Using the remedies of color and shape, Kandinsky wanted to bring about spiritual restoration. And he was confident that his audience wanted the same. He hoped, he said, that those seeing his paintings would "turn away from the soulless life of the present towards those substances and ideas which give free scope to the non-material strivings of the soul." ⤳

Jason Landsel is the artist for Plough's *"Forerunners" series, including the painting opposite.*